Watercolor Techniques

TONY COUCH

Watercolor Techniques

Cincinnati, Ohio

Tony Couch Watercolor Techniques. Copyright © 1991 by Tony Couch. Printed and bound in Hong Kong. All rights reserved. No part of this book may be reproduced in any form or by any electronic or mechanical means including information storage and retrieval systems without permission in writing from the publisher, except by a reviewer, who may quote brief passages in a review. Published by North Light Books, an imprint of F&W Publications, Inc., 1507 Dana Ave, Cincinnati, Ohio 45207. First edition.

95 94 93 92 5 4 3 2

Library of Congress Cataloging in Publication Data

Couch, Tony. Watercolor techniques / Tony Couch — 1st ed. p. cm. Includes index ISBN 0-89134-389-x 1. Watercolor painting — Technique. I. Title. ND2420.C68 1991 751.42'2 — dc20

90-21068 CIP

Edited by: Greg Albert

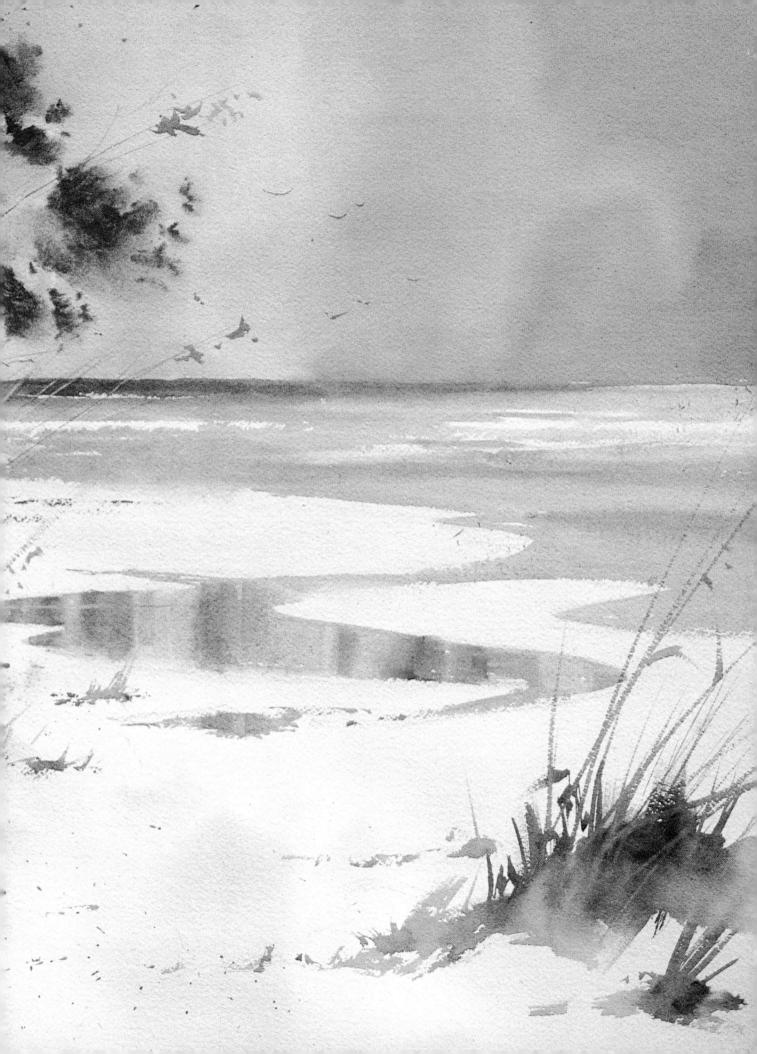

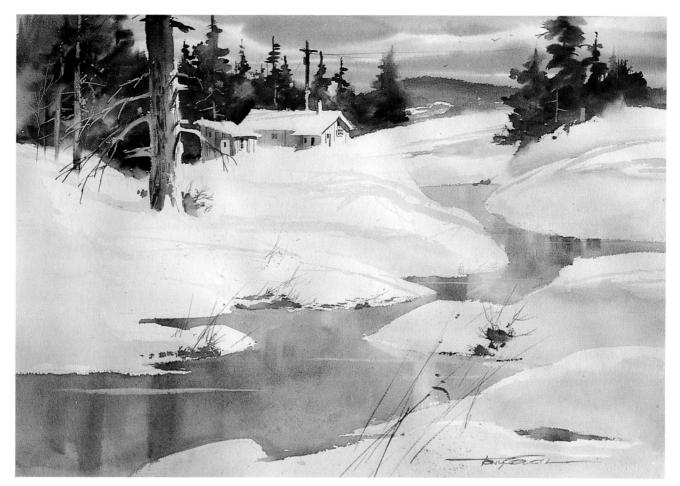

Frozen Pond II 22" x 30"

Contents

Introduction VIII

Trees Without Foliage 6 Learn to paint the skeletal structure of trees, a basic component of watercolor landscapes

2 Trees With Foliage 12 Paint convincing trees in full foliage without having to paint every leaf

Weathered Wood 18 Master the most important techniques for creating texture in watercolor

Barn 24 See how the principle of gradation makes even a simple barn into an eyecatching painting

Weeds 30 Learn these simple but effective ways of painting weeds, reeds and tall grasses

Rocks 36 Learn to use color, shape and edge quality to render the solidity of this common landscape element

7

3

4

5

6

Palm Trees 42

Discover how to simplify the distinctive form of the palm tree and paint it in a few decisive brush strokes

Still Water 48 Capture the serenity of placid water with a graded wash and defily painted reflections

9

8

Water In Motion 54

Express the movement of rippling water and the glint of sunlight upon it, with the proper brush techniques

Snow Scene 60

Learn the basic techniques for painting the quiet solemnity of the winter landscape

Index 87

INTRODUCTION

How to Use This Book

his is a new kind of book. It's not the usual art instruction book with which you may be familiar. Instead of merely reading about how I paint, here you have the opportunity to paint along with me.

This book is designed to allow you to study—and improve—just one thing at a time. By breaking the process of watercolor painting into small bits, this book allows you to learn one technique at a time without frustration. The practice templates are designed so that you can trace them over and over until you feel confident drawing them on your own. You can work at your own pace.

The Value of Practice

It has been said many times that there is no shortcut to competence in any field; no substitute for practice, practice, and more practice. This is nothing new. What separates the successful artist from the dabbler, however, is not just how long he practices, but how long he practices smart.

This book will help you practice smart. You will learn how to paint the basic components of the landscape. It's like learning a new language; you'll add important words and phrases to your painting vocabulary that you can use later to tell your own stories in paint.

Every part of the book is designed to be used. There is the introduction (you're reading it now). Then, for each project, there are five instruction sheets: four steps and a full-sized reproduction.

Each project does two things for you: (a) It gives you a drawing from which to work, and (b) It provides you with a finished example to emulate, so you always know exactly what you're trying to achieve.

I suggest you read through the entire book

first to familiarize yourself with its contents. Then read the procedure pages carefully. When you feel you understand them, you're ready to tackle your first project.

You may want to follow these step-by-step instructions closely the first time as they contain a lot of detail vou need to know before vou paint. Then copy my example as well as you can. The next time you practice this same project, vary the hues and values as you see fit to make your own discoveries. Remember most objects can be almost any color within reason; not necessarily those I used. In fact, if I were to do each project again, I can assure you there would be differences in the colors. Then try it without tracing the template; make the drawing as similar or as different as vou wish.

After you understand whatyou're going to attempt, the next step is to copy my drawing onto a piece of watercolor paper. Do it freehand if you're able; otherwise trace it. Here's how:

Turn the template face down. Using the side of a sharpened soft pencil, cover the back of the template with graphite. Then rub with a tissue until vou have an even coat of graphite all over. Turn the template right side up and lay it over a piece of watercolor paper. With a pencil trace over the preprinted lines on the template using enough pressure so that the graphite on the back is deposited upon the watercolor paper. Try not to smear this graphite. If you do, clean it up a bit with a kneaded or plastic eraser.

You can also use regular carbon paper to transfer this drawing. Although both graphite and carbon paper transfer marks that are water repellent, the drawing is not heavy or complex enough to make a difference.

Materials and Tools

In general, the simpler the tool, the more useful it'll be. You'll need the following items for the projects in this book; they are also a good basic list for almost any painting project:

Paper

These practice projects can be done upon any paper that will accept water without wrinkling uncontrollably, but as a practical matter it should be paper made for watercolor. For one thing, nothing else will contain the wrinkling, and for another, it's impossible to get the textural results you see in this book on anything but traditional watercolor paper with a coldpress finish.

Watercolor paper comes in loose sheets or together in a block. Probably the block will be more convenient for you in the beginning. The block is a pad of watercolor paper glued together on all four edges. It's the same paper as the loose sheets and the blocks come in a variety of dimensions. You can work on the top sheet and, when finished, slide a knife or letter opener all around the edges to remove it and uncover a clean sheet beneath. The advantage of the block is that you don't have to stretch the paper. Although it will buckle a little as you paint wet passages, it'll always dry perfectly smooth again. A 10"x14" block of cold-press paper will work fine for these projects.

If you work on loose paper, you'll find that 140 lb. and 300 lb. sheets are the best. The heavier weight means thicker paper. You may find some 75 lb. paper but it's too thin to be practical for most painting. You'll find three finishes: hot-press (smooth), cold-press (medium rough) and rough (very rough).

Many painters like 300 lb. paper because it won't wrinkle as you paint; 140 lb. paper will wrinkle a little, but this minor inconvenience can be eliminated by stretching it first. Soak the whole sheet (both sides), wait about five minutes for it to expand, then fix it on all four sides to a hard-surfaced board with tape, staples, or office clamps and let it dry stretched to this expanded size. It can't wrinkle after that.

In case you're interested, I notice most pros use Arches, 140 lb., with a coldpress finish. These projects were painted on that paper in a 10"x14" block

Board

If you paint on loose sheets, you'll need a board to which the paper should be attached. It should be about 1/4" larger than the paper on all four sides so that office (Bulldog) clamps can hold the paper to the board. This board should be of some waterproof material such as Lucite, Plexiglas, Formica, or plywood coated both sides with waterproof varnish. If you tape or staple the paper, the size of the board doesn't matter, but it must be made of a material that will hold the staples or tape.

Paint

Iuse paint in tubes. You won't

need the most expensive brands; Liquitex, Grumbacher "Academy," and Winsor & Newton "London," are fine. The following hues are ones I used for the projects in this book.

> Hansa or Lemon Yellow Cadmium Yellow Medium or New Gamboge Raw Sienna or Yellow Ochre Burnt Sienna Cadmium Red Medium or Grumbacher Red or Chinese Red or Vermilion Alizarin Crimson or Rose Madder Ivory Black Ultramarine Blue Thalo, Winsor, Prussian, or Antwerp Blue.

Palette

Any palette with a cover will do. The cover keeps the paint moist for a few days, and if you spray the paint with water every fifth day or so and replace the cover, it will last indefinitely. You need rich washes when you paint, and saturated color from a dried hunk of pigment is just not possible. I use a Robert E. Wood palette; others, like the John Pike palette, will work as well.

Brushes

I recommend nylon or a nylon blend. They're much cheaper and in my opinion equal to sable hair. You only need a few brushes for these project paintings; here's what I used:

> #3 rigger (Winsor & Newton series 530 is a good one) #6 round #12 round 1/4" flat

1/2"flat 1" flat

In general, I use a round brush for round shapes and a flat for angular or rectangular ones. Keep it simple.

Sponge

This is an essential piece of equipment for control; it's used every time you dip the brush into paint or water. I like to use a damp 6"x4"x2" cellulose sponge to draw excess water from the brush after it's been in the water can for any reason. A wad of facial tissue will work as well. You could also flatten a roll of toilet paper (so it won't roll away!) for this. A pad of paper towels works pretty well, too.

Miscellaneous

I also use a variety of tools for special effects. I use an ordinary pocketknife to scrape lines into moist washes. I use a single-edge razor blade to scrape color on and off to squeegee out rectangular shapes in a still wet wash, or to stamp in fine lines. With the corner of it I can pick out specks of white paper from a medium- or dark-value wash (snow, etc.). I have a diamond-shaped oil painter's palette knife which I use as a pen to scratch in fine lines or to indicate branches and twigs for a tree. I keep a hair drier handy to speed the drying time of washes on occasion.

Simplifying Color

Color has three dimensions: hue, value, and chroma. Hue is that characteristic that distinguishes one color from another: blue, green, purple, etc. Value is the lightness or darkness of color. Chroma is the brightness or intensity (sometimes called saturation) of a color, vs. duller or "grayed" color.

Hue

There aren't as many, nor is the subject as complicated as you may have been led to believe. There are only ten families of hue:

> red orange yellow yellow/green green blue/green blue blue/purple purple (violet) red/purple

They are usually arranged in a circle called a color wheel. Every color you can imagine is either one of these ten or is only a variation of one.

You may wonder about the absence of names like Thalo blue, Winsor red, Acra violet, and the like. These are pigment names created by paint manufacturers to identify a variation. They're useful when buying paint, but complicate the job if you paint in those terms. It's much simpler when painting to think only of the basic ten. Then, (a) is it lighter, darker, or the same as the parent? (b) Is a little of the adjacent hue mixed with it?

Those two questions will quickly identify any color on earth. "What you see is what you've got." And you don't have to memorize any litany the paint salesmen use.

Color is arranged on the color wheel so that those we associate with fire or heat,

such as red, orange, and yellow are on one side, and those we associate with cold and water, such as blue and purple, are on the other. We call this color temperature.

Avariation of this idea is a convenient way to describe one color's relationship to another. Accordingly, although purple is forever a cool color, if we mix red with it (red/purple), it can be called a warm purple compared with its parent. Similarly, mixing blue with it (blue/purple) would make it a cool purple compared with the parent purple.

The primary colors (red, blue, and yellow) and the secondary colors (green, purple, and orange) will each have a warm and cool version, even though any red, yellow, and orange remains warm and any blue and purple remains cool.

So where is green? Well, green happens to be right on the border between warm and cool, so a simple way to look at it is to consider it something special. A character. "One of a kind." That's because it can be cool, warm, or neutral: Middle green, as found on the color wheel, is neutral. If a little yellow is mixed with it (yellow/ green), it immediately becomes warm—compared with green or any other color. If a little blue is mixed in (blue/green), it immediately becomes cool—compared with green or any other color.

Value

Value is the lightness or darkness of any color and is usually described with a scale of ten values; 1 being the darkest color (black) and 10 being the lightest (white). Most of the colors in your palette are in the mid-value range—about value 4 or 5. The exceptions are yellow and orange, which are at the light end—about value 9 and 8.

Chroma

Any color is at its maximum brightness, or intensity, as it comes from the tube. You can't make it any brighter, but you can make it less intense, or "gray it down." Nothing in nature is as bright as paint from the tube except flowers and fall foliage. The rest are grayed down, so it is useful to know how to weaken or gray your colors. There are three ways to do this: You can (a) mix it with its complement, or (b) mix a little black or gray with it, or (c) mix a little water with it (it'll also become lighter in value.)

Setting Up a Palette

Armed with this knowledge, you can make up a palette of a few hues that you can use for any painting, yielding any color you might imagine. This palette will include, of course, the three primaries (red, blue, and yellow). However, instead of using the color closest to the spectrum hue, I'd suggest a pair for each: one on either side of the spectrum color. Or, as we discussed under "Hue" earlier, a warm and a cool version of each.

So instead of a dead center red, I have two reds: a cool red tinged with purple (alizarin crimson, or rose madder) and a warm red kissed with a bit of orange (crimson red medium, or Grumbacher red, or Chinese red or vermilion).

I have two blues: one with abit of green (Prussian, thalo, Winsor or Antwerp blue), the other with a touch of purple (ultramarine or French ultramarine).

And I have two yellows: One flirts with orange (cadmium yellow medium or new gamboge); the other has something going with green (hansa or lemon yellow).

The advantage of having

two of each is for purposes of variation: If I use the cool blue in one area, when I need blue in a nearby area I'll use the warm blue.

The rest of your palette might be made up of colors that you use often. They could be mixed from these primaries we just covered, but for the sake of ease most painters will have a few of these favorites. I use raw sienna (or yellow ochre), burnt sienna for my brown, and I use ivory black. Don't use black for black areas; rather, mix it with water for grays. These grays are used for gray areas, to "gray down" the chroma of colors, and to make any color darker. Mixed with either yellow it produces an olive green.

I haven't mentioned green for the palette. I do have a thalo green (blue/green) in one corner but I use it rarely; usually for sea water or shallow water around tropical reefs. For any foliage I mix blue and yellow for my greens for much greater variety than available from a tube of green.

If I want a brilliant green, I add my cool blue to a warm vellow (for instance, Prussian and new gamboge). If I need a warmer green, more yellow goes into it. For a cooler green; more blue. If I substitute the cool vellow for the warm yellow (hansa or lemon yellow) I'll still get green but it will be much more drab. The reason is that whereas any cool blue (Prussian, thalo, etc.) is a stain, thus a great mixer, the cool yellow is not. Similarly, substituting the warm blue for the cool blue (the great mixer) nets another dull green. Try it.

Making Paint Behave

If watercolor has a reputation for being difficult, it is due to the notion that it's hard to control. It seems to have a mind of its own and it is unforgiving to any who try to tame it. However, you can control watercolor if you understand its nature; how it behaves when the paper is wet—and what it'll do when the paper is dry.

Watercolor can be applied in only four ways: You can apply it with a dry brush on dry paper; a technique called dry on dry. Or you can use a wet brush on dry paper; a technique called wet on dry. A dry brush on wet paper is dry on wet and a wet brush on wet paper is wet on wet. It is these last two methods that have given watercolor its "tough" reputation.

To control wet on wet and dry on wet, think of the brush and paper as sponges. A sponge works by sucking up water when it's damp; water will move from a place that is wetter to a place that is dryer. So if the brush is dryer than the paper, water will be sucked up from the paper into the brush. If the brush is wetter, the paper will pull the water from the brush. Pigment will be deposited onto the paper no matter which way the water flows.

For both the wet on wet and dry on wet techniques, the paper must be freshly wet—with a glisten on the surface—not just moist. If the paper is merely moist (no glisten) there is danger of a backrun. A backrun is a watermark that occurs when a wet brush floods damp

paper (the dryer paper pulls water from the brush), picking up loose pigment that hasn't yet settled into the fibers of the paper and forming a round, light "flower" that dries with a dark, hard edge.

Wet on Wet

If you are painting wet on wet, the paper and the brush are very wet and neither acts like a sponge. Water and pigment will flow from the brush to the paper by the pull of gravity. The color will diffuse uncontrollably into the water on the paper, creating wonderful soft shapes. The artist can use this effect for skies, reflections, backgrounds, and similar areas.

If there is more than one color on the brush, they will diffuse onto the paper with unpredictable, but always attractive results. One way to gain this effect is to dip each corner of a flat brush into two different colors. (Caution: Your paint must have the consistency of toothpaste, or softer! If you're working with dried up blobs of paint you'll get nothing for your efforts.) Then push, pull, and twist the brush to mix the color right on the soaking wet paper.

Once you have color sloshing around on the paper, it will continue to change and diffuse for several minutes even though you are no longer painting. Stay out of it! Let it follow its own laws; it'll do something far more beautiful on its own. You can't make it any better; only worse.

Dry on Wet

Unlike wet on wet, which

INTRODUCTION

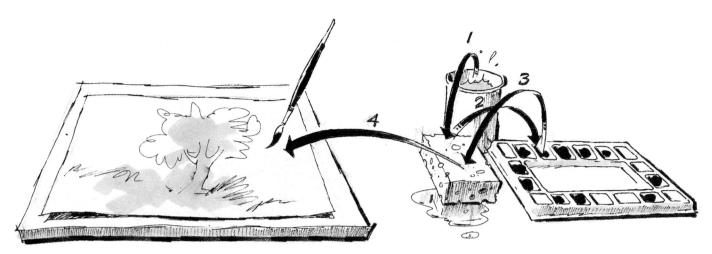

while producing exciting results is largely uncontrolled, dry on wet is the key to controlling this medium. When a damp (not wet) brush laden with a strong charge of pigment (of about toothpaste consistency) touches wet paper, the water on the paper is sucked into the damp brush (it's the better sponge of the two) while the pigment goes onto the paper. Since the damp brush has done a little drying of the paper as it deposited the pigment, this paint cannot run nearly as far as it would if the brush were wet, hence a measure of control.

Here's how you may paint dry on wet: First clean your brush in the water can, then press it onto the cellulose sponge (facial or toilet tissue will work as well) until all the water you can get out of it is sucked into the sponge.

Scoop up some paint on one side of the brush only, roll it over, and press the brush onto the sponge again so that any water picked up from the palette is absorbed by the sponge. Now you have a dry (actually slightly damp) brush loaded with paint that will more or less stay where you put it on the wet paper, yet will have soft edges.

The key to dry on wet is that sponge. The brush is pressed onto it twice: Once before and once after it picks up the paint. (See the diagram above.)

Dry on wet allows control, soft edges, and transparency with an ease no other medium can rival. Once in the habit of keeping the paper wet and using the sponge to keep the brush dry, you can make watercolor behave.

Texture

Objects almost always have one or more of three characteristic textures: hard (smooth), rough, and soft. Trees and rocks, for example, are always hard or rough. never soft. Snow, clouds, and ocean spray are always soft. with a bit of rough, but never hard. A guide for identifying the characteristic texture for an object might be to imagine what its surface would feel like if you put your hand on it. It will be either hard (smooth), soft, or rough.

Although texture inside shapes can greatly enhance a painting, the identifying texture must be at the edges since that is where we first identify shapes.

To create either hard or rough texture, it helps to understand the surface of the paper. Cold-press watercolor paper (which I used for these projects) has a medium rough surface. If you could see a cross section of it with a magnifying glass you would observe an expanse of hills and valleys.

Hard (Smooth) Texture

To produce the illusion of hard (smooth) texture, you must cover the hills and valleys with a fairly liquid wash. The paper must be dry, but the brush must be about half loaded with water and plenty of pigment so the mixture will flow into the valleys.

Now, with the brush perpendicular to the paper slowly move along the paper and you will produce a shape completely covered with paint, with a smooth, hard edge to it. The brush is wet, held perpendicular to the paper, and moved slowly to ensure the paint covers the hills and valleys.

Rough Texture

To produce the illusion of rough texture, only the hills should be painted; the valleys must be left unpainted. To do this, you need change only one of the three things you did when painting hard texture—and it doesn't matter which you change. For hard texture the brush was perpendicular, half wet, and moved slowly.

You can change the angle. With the same wet brush and speed, go from perpendicular to the paper to some angle to it. The wetter the brush, the more acute the angle must be to produce rough texture. You may have to make it almost parallel to the valleys, so it paints only the hilltops, creating rough texture.

You can change the speed. With the same wet, perpendicular brush, make a fast stroke. Now the brush hits the hilltops but doesn't have time to get down into the valleys, again creating rough texture.

You can change the half wet. With facial tissue or a cloth or paper towel, squeeze all the water you can from the heel of the brush, without disturbing the pigment at the tip. Now the brush is dry. Make any kind of mark on the paper, in any way. If there is pigment in the brush it will paint only the hilltops, once more creating rough texture.

Soft Texture

It's only necessary for the paper to be wet to create soft (diffused) texture. The brush must have pigment, of course, but can be anything from dry to soaking wet. The more water in the brush and on the paper, the softer the edge of the shape will be.

Going from Hard to Soft Edge

Making a hard edge soft is a little different. When you lay a wash on dry paper, the edge forms a clean, crisp demarcation between the wet, painted area and the dry, unpainted area. To soften such an edge, it must be still wet from its initial wash. With a brush laden with clean water, wet the dry paper below the edge of this wash and immediately work it up into the still wet pigment. The color of the wash will gently diffuse down into the clean water area, making a soft edge here. Immediately clean and dry the brush with facial tissue, then sop up the water at the bottom edge of the clean water area. If this last step is left out, the color sifting out of the original wash will find the edge of the clean water area and give you a new hard edge!

The trick in all this is to do it while the initial wash is still wet at that edge. Sometimes it means working very quickly.

If a hard edge is already dry, there are still ways to soften it. One is to wait until the edge is completely dry, then erase it into a soft edge with a hard eraser (office pencil). Careful: Don't rub hard enough to damage the paper!

None of these alternate methods are as attractive as the one first described. In fact, I regard them as a last resort and rarely use them.

Lift and Scraping

A lift is a technique for making an area a lighter value by lifting out pigment with a thirsty brush. It must be done immediately after the initial wash is laid on the paper while it is still wet. Rinse a brush and squeeze out all the water, so it will act like a sponge, then lay it on the still wet wash. With one continuous stroke suck up some of the paint, leaving a lighter version of the same color in place.

Lifts are useful for creating a sunlit side of an object or to suggest reflected light on a surface close to the ground, a roof, or other surface.

The lift will create a softedged shape. If you want one that is sharp edged, you can scrape some of the still wet paint away with a sharp, flat tool such as a single-edged razor blade. You have more time to make a scrape than a lift, because the hard scraping tool will remove more pigment out of a wash that has begun to dry than a soft brush.

If I want a narrow light line scraped into a dark wash—such as tree limbs or weeds on a dark background—I use the point of a pocketknife or any other sharp tool.

Stamping and Dragging

A useful technique for creating fine straight dark lines on a lighter surface is stamping or dragging the thin edge of a single-edge razor blade or credit card perpendicular to the paper and in the direction of the line. Caution: The paper must be dry, or the line will diffuse into something else.

Splatter

A time-honored and effective technique for quickly creating texture upon a surface is splattering paint onto the paper with a brush.

Use any brush—from a small round to a 1" flat, loaded

with pigment and plenty of water. Hold the brush horizontal to the paper and just high enough to allow four fingers of your other hand underneath it. Lift up the brush and rap the ferrule (the metal part) so that the paint splatters onto the paper.

If the paper is dry the splatter will stay where it lands. If the paper is wet, it'll diffuse into soft spots. Keep the brush low so it won't go too far; put a piece of paper over any part you don't want splattered.

A toothbrush dipped into a "soupy" mixture in your palette and held close to the paper while you run your thumb along the top of the bristles will make a finer spray of small dots.

Fine Lines

A rigger is a small round brush with long hair. It is useful for indicating small branches and twigs, telephone lines, and the rigging of ships (hence the name).

When I am painting twigs and small branches, I support my rigger hand with my other hand whose fingers are made into a tripod and rest upon the paper. Then I can flick the rigger away from the tree trunk, in the direction of growth of the twigs making straight, tapering lines.

I sometimes use an oil painter's palette knife to paint twigs. I pick up watercolor on its tip and use it like a pen. Still dragging and flicking away from the tree trunk, as with the rigger, it leaves a scratchier, more realistic twig.

Get Ready to Paint

Once you have read over these projects, you're ready to paint. Begin with any project. Arrange a comfortable place to work, with good lighting, and plenty of space to spread out your gear. Put on your favorite music, put out the cat, take the phone off the hook and R E L A X as you paint.

To see the techniques in this workbook and others in action, write: Tony Couch Videos, 5860 Musket Lane, Stone Mountain, Georgia 30087

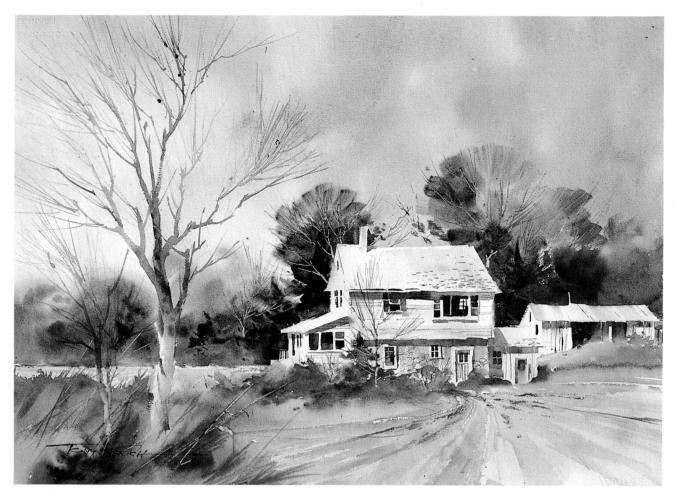

Back Home 22" x 30"

The true beauty of transparent watercolor is its fresh, spontaneous appearance. The way to achieve this quality is to paint simplified "symbols" for objects, rather than to attempt to paint every little detail. The watercolor painter is always inventing symbols for the things he wants to paint, symbols that identify the object without reporting all the specifics. Here we will learn how to paint a typical hardwood tree that has lost its foliage. It is a symbol that says "tree" rather than describes a real tree. Once you learn how to paint this simple example, you can vary the pattern to paint a particular tree. By mastering this standard tree, you can avoid the unconvincing trees which often plague the beginner. (Use template on page 67.)

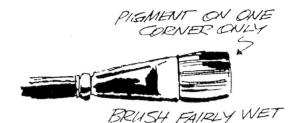

se a clean brush and water to wet the trunk until it is glistening, so that when you add paint, it will diffuse readily. Wet a small flat brush (about the width of the tree trunk) with clear water, and charge one corner of the bristles with burnt sienna so that you have a very wet brush with paint in one corner and clean water in the other. Then, putting the paint-laden corner of the brush on the outer edge at the base of the trunk and the water-bearing edge toward the sunlight, move

the brush upward running the charged edge of the brush along the dark edge of the tree in one continuous stroke. The wetness of the trunk will cause the paint to diffuse toward the sunlit edge with a soft transition from dark to light. The dark edge, which is on dry paper, will be rough textured. Try

not to have a trunk that is half dark and half light; rather, one side should be larger (dominant). While the trunk is still wet but after it has lost its glisten, you might use the tip of a pocketknife to scrape slightly rounded horizontal marks into the bark to describe the roundness of the trunk.

STEP ONE

- Wet the trunk with water until it glistens.
- 2 Load one corner of a small flat bush with a dark brown.
- **3** Paint the tree trunk in one stroke, from the base upward.
- 4 Scrape horizontal marks into the bark.

TREES WITHOUT FOLIAGE

w paint in the limbs. Since you want to have soft edges where the limbs come out of the trunk, you may need to wet these points on the trunk with clean water if the paint has dried since the last step. To achieve an interesting variety, you should give the limbs a different color and a darker value than the trunk. I suggest a cool color to contrast with the warm of

the trunk. Using a small round brush for the limbs, start at the trunk and paint the limbs upward, at roughly a 30 degree angle. Notice that the limbs are positioned so the angles are varied while still pointing upward and the spaces between them are unequal. Notice also that there are no limbs directly opposite each other on the trunk. To make a limb or twig look like it is coming toward you, make it originate inside the trunk like the lowest limb on the left.

STEP TWO

- 1 Wet the areas where the limbs grow out of the trunk.
- 2 With a small round brush, paint the limbs in a cooler, darker color.
- 3 Make the limbs straight, not curved, and vary the angles and the spaces between them.

sing clean water, wet the paper on both sides of the base of the trunk, but not below the ground line. Mix some yellows, browns, and blues on the palette but don't blend them. With a flat brush, pick up a bit of each color and brush it into the still glistening paper at the sides of the trunk. Push the tips of the bristles at a low angle against the dry paper along the ground line to get a rough texture.

Paint the background color darker along the light edge of the tree trunk for contrast. By stopping inside the wet areas, you can achieve soft edges along the top and outside edges of the background. While the background is still wet but has lost its glisten, use the point of the pocketknife blade to scrape in a few weeds. When the trunk is dry, paint in the shadows cast on the trunk by the limbs. Use the small round brush and cool colors. The shadows should be dark and hard edged at the source, but softer as they move down the trunk. Use a round brush wet with clear water to soften the cast shadows while the paint is still wet, so they will disappear into the shaded side of the trunk.

STEP THREE

- Wet the paper around the trunk, above the ground line.
- 2 Mix some yellows, browns, and blues and paint in the background.
- **3** Use the pocketknife to scrape in weeds.
- 4 Paint the shadows cast by the limbs onto the trunk.

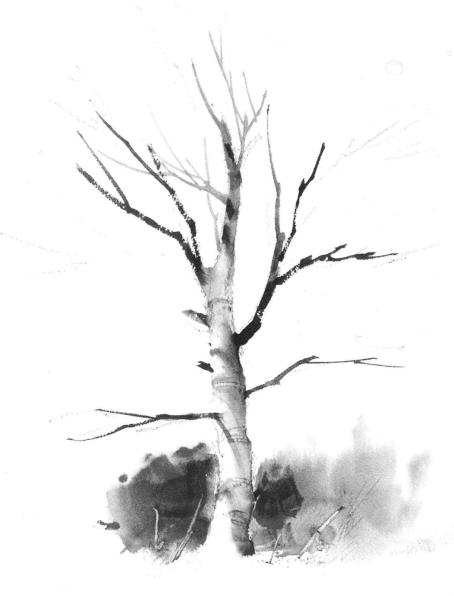

TREES WITHOUT FOLIAGE

he small branches and twigs can be done with either the rigger or the tip of a palette knife. Holding the brush by the end of the handle, start each twig or branch from the trunk or limb and flick paint outward in the direction the tree grows toward the sky. The twig will be thick and dark at the base and thin and rough at the end. Remember to vary the color and spacing for interest. When using the palette knife, pick up a bit of paint with the tip and stroke it on the paper as you would a brush. The palette knife will make a scratchier line. You might also want to use the rigger to paint in a few shadows cast by the twigs on the trunk in a direction consistent with the light source (in this case the light is from the left, with the shadows going down to the right).

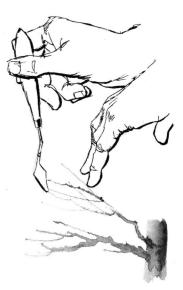

STEP FOUR

- Use the rigger or a palette knife to add branches and twigs.
- 2 Paint the twigs straight and in the direction they grow.
- 3 Vary the color and spacing for interest.

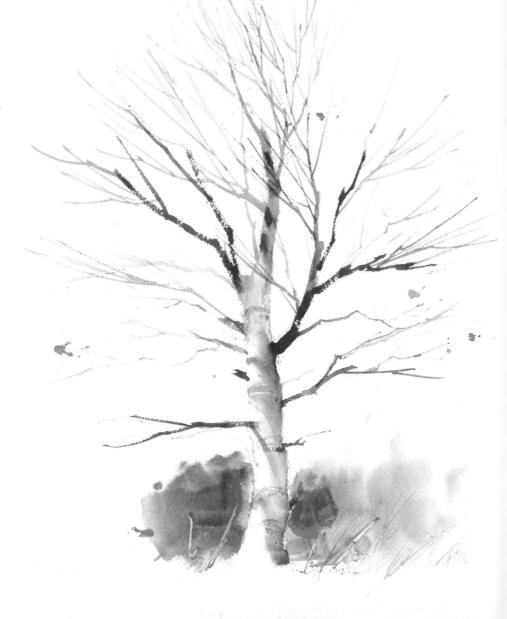

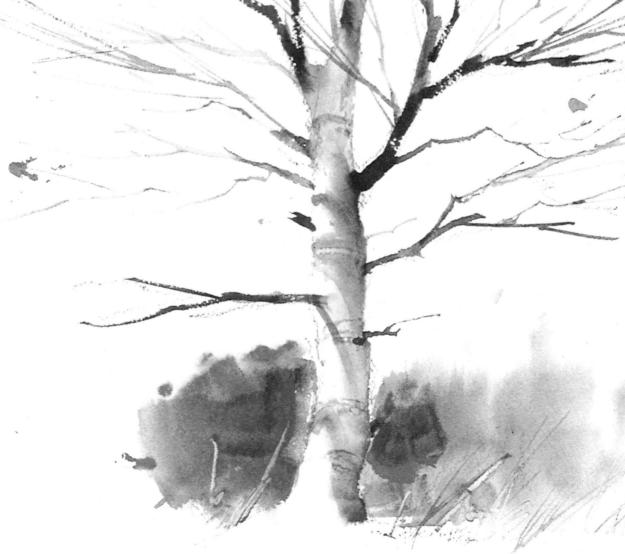

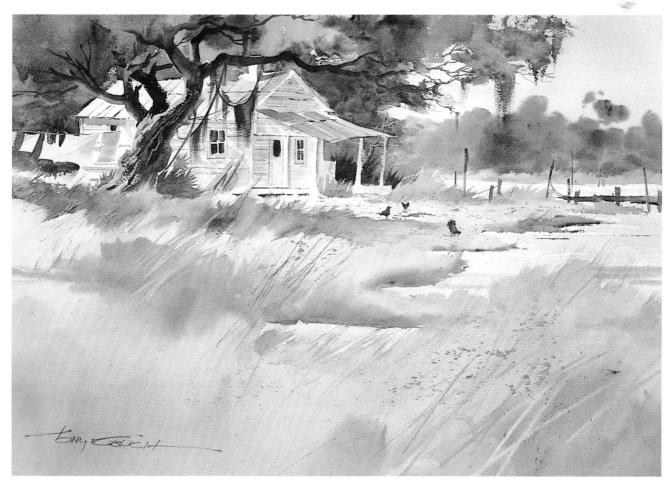

Summertime 22" x 30"

2 Trees With Foliage

If you want to paint glorious landscapes in watercolor, you must learn to paint trees in full foliage. This project will show you how. Remember, I'm not going to show you how to paint any particular tree; I'll show you how to make a symbol that will include all hardwoods. To do this, you must forget all the individual leaves you see on trees and simplify them into large masses or clumps of leaves. You don't have to paint a single leaf! As you gain experience with this generalized tree, you will soon learn how to modify it to represent a specific tree, and trees will become a real pleasure to paint. (Use template on page 69.)

et the interior of the leaf masses with clear water, leaving the edges dry. Using the big (#12) round brush, mix the vellow with orange in it and the blue with green in it (new gamboge and Prussian blue), to get a mid-value green. The brush should be wet with color but a bit drier than when you wet the paper with clear water. Don't mix the colors completely, either on the palette or on the paper. Quickly push and twist the brush into the wet paper with as few strokes as possible, letting the color diffuse. Push the color out to the edge of the leaf masses. To get a rough texture at this edge, push or drag the tips of the bristles against the dry paper with the brush at a low angle. Do this once and leave whatever effect you get. Don't fool with it. You can't make it any better. You can only lose the freshness by fiddling. Now, quickly, while the paint is still wet, go on to step 2.

STEP ONE

- With a big round brush, wet the leaf masses with clean water, avoiding the edges.
- 2 Mix the yellow with orange in it and the blue with green in it.
- **3** Push and twist the paint into the wet leaf shapes.

PUSH. PILL and TWIST

TREES WITH FOLIAGE

Rest, go for the dark values. Add more blue or add black, brown, or a combination of all three to the green used in step 1. Let the colors blend on the palette a bit, but don't mix them. The colors should be darker than the light values but lighter than the dark value you will need for the branches. Use the big round brush again, but keep it fairly dry with a good amount of pigment because you want

to employ the dry on wet technique. You can put the dark values almost anywhere, but avoid the sunlit tops of the leaf masses and the uppermost canopy of leaves. You're depicting a few dark holes in the interior of the foliage, and the dark underside of a few of the clumps of leaves.

STEP TWO

- Useblue, black, or brown or a mixture of these to darken the green.
- 2 Paint in the darks, avoiding the sunlit areas.

et the leaves dry, then wet the interior of the tree trunk with clean water, avoiding the edges where we will want rough texture. Determine the direction of the light, so that the shadow side of the trunk will be consistent with the light on the leaves. Paint the dark shadow side of the trunk with the wet on wet technique. If this dark doesn't diffuse enough to make the trunk look round, use a clean wet brush to blend the color with the wet of the trunk to get a soft edge where the shadow meets the light. Add some color changes for variety in the trunk and limbs. I added blue. Don't paint the trunk into the leaves; instead, leave a soft edge where the trunk ends and the leaves begin to make it disappear into the foliage. Paint the ground under the tree using whatever color you want the grass and weeds to be, but make it darker directly under the tree and off to the side where the shadow would fall.

STEP THREE

- Wet the tree trunk with clean water, avoiding the edges.
- 2 Paint the shadow side of the trunk in one stroke.
- **3** Paint the ground using any color that describes grass and weeds.

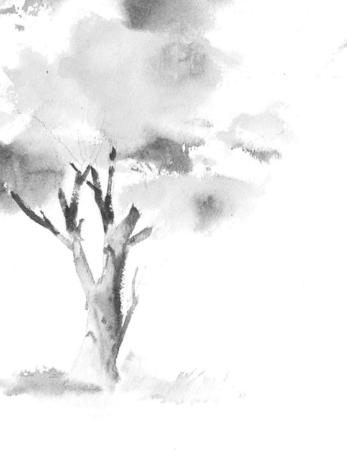

TREES WITH FOLIAGE

ix a dark color for the limbs and small branches. It doesn't matter which color as long as it is darker than the darkest leaves. Paint the darker limbs over the dark leaves and over the white gaps where the sky is visible, but stop where the leaves are light. It will then look like the limbs and twigs are in front of the dark leaves and behind the light ones. Using a brush wet with clear water, soften the ends of the limbs

and branches while they're still wet where they disappear "behind" the light leaves. A small round brush (#8) is good for the larger limbs and the rigger for the twigs. Using a rigger brush, begin each stroke at the branch where a twig originates and lightly flick the tip of the rigger away from the branch, in the direction the twig is growing. Also add some weeds and grasses under the tree by the trunk, and add a few small dots and splatter for texture in the foliage and weeds. As a final touch add one branch or so coming out of a light mass of leaves to get a greater sense of volume.

STEP FOUR

- 1 Mix a dark color for the limbs and small branches.
- 2 Paint the limbs over the dark leaves, but not over the light ones.
- 3 Flick in branches with the rigger.
- 4 Add weeds, grasses, and splatter for texture.

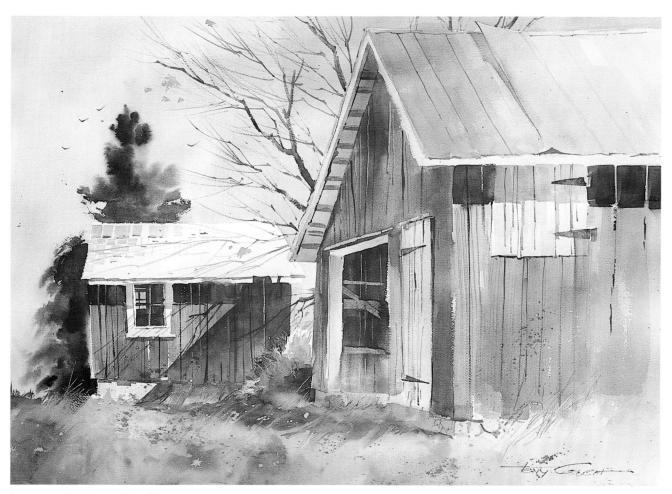

```
Barns and Shadows 22" x 30"
```

3 Weathered Wood

Watercolor is a marvelous and versatile medium. A lifetime isn't sufficient to learn all it can do. Creating textures is one of the things at which watercolor excels. In this project, you will learn how to paint the fascinating textures of weathered wood. You will learn several techniques that can be used to create many other textural effects, including scraping, lifting with tissue, splattering, and using a razor blade and a splayed brush. (Use template on page 71.)

et the area in the foreground with clean water well up into the bottom third of the wood. With a large (1/2 inch or so) flat brush, add a light wash of yellow ochre or raw sienna on one side and blend to any cool color at the right to add variety. Go directly to the next step while the weeds are still wet.

STEP ONE 1 Wet the fore

Wet the foreground with clean water.

2 Add a wash of warm yellow changing to any cool color

y ou want a soft edge where the wood goes into the foreground weeds, so these weeds must be still wet. If they're not, allow them to dry completely, then rewet them. Using your largest flat brush and clear water, wet the entire area of wood until it glistens. Then paint in various warm and cool colors. Don't mix the colors on the palette, but let them intermingle on the paper with a wet on wet technique, keeping the values in the mid-range. As you paint from left to right, vary the color and value. I changed from a dark red to viridian. The exact color isn't important, but it should become darker toward the right.

Flick the brush down into the still wet weeds. Then squeeze all the water out of the brush and lift out some lighter wood color in the same area, in the shape of the weed masses. When the weeds have lost their glisten but are still wet, use the tip of the pocketknife to flick up some weeds into the wood and foreground.

STEP TWO

- Wet the wood area with clean water.
- 2 Paint the fence in various colors, letting them blend, getting darker toward the right.

Use a dark color to flick weeds onto the wood and scrape in more weeds with a pocketknife.

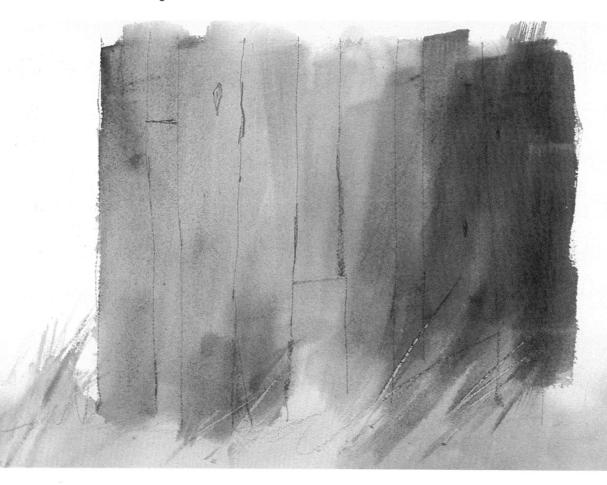

3

ix some dark color on the palette using staining colors like alizarin crimson and viridian green, which will penetrate the paper and not lift easily. It will need to be a very dark value, but the exact color isn't important. Use the rigger or small round to paint in the knotholes with this mixture. Then squeeze the moisture out of the large (1" or so) flat brush and dip it in the staining mixture so the brush is wet but not saturated. Use a pocketknife to separate the hairs of the brush so you can use the splayed hairs to make the vertical streaks of the wood grain in one stroke. Start each stroke at the top and paint down so that the hairs leave individual trails simulating the wood grain. Go around the knotholes. When you get to the bottom, use a clean wet brush to soften the graining into the weeds.

When this is dry, wet the small areas of wood that are

STEP THREE

- 1 Mix a dark value using staining colors.
- Use a small round brush to paint in the knotholes.

in sunlight with clean water. Make the shapes varied in size and at irregular intervals. They should be slanted toward the sun. Let the water soak in and soften the pigment for about a minute. Use a facial tissue to blot out the color in the wet area. Repeat this wetting and wiping process until these "sunlit" areas are about one half the value of the wood.

Splay the hairs of a 1" flat brush to make the streaks of wood grain.

3

Wet small areas and wipe with tissue. Repeat as necessary.

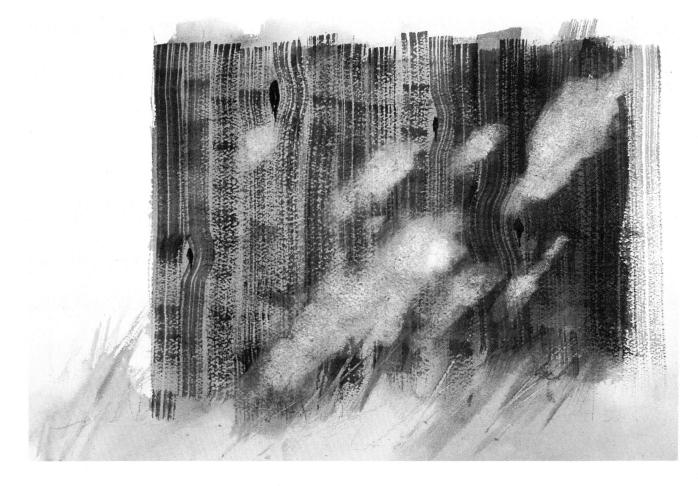

sing the rigger or the flat brush with the hairs splayed, restore the grain with the same stain mixture as before. Mix another dark (I used Prussian blue and burnt sienna) to paint cracks between the boards. Remember to vary the thickness of the line to make it more interesting. Darken the knotholes to make them stronger and reinforce the grain if necessary. Finally, for some texture, use the round brush with a very dark color and splatter the boards a bit. Easy does it. Don't let the splatters form a boring straight line. Let the painting dry, then use the corner of a razor blade to scrape in some highlights on the sunny side of the knotholes and boards. Burnish the scrapings with a soft eraser. Use the rigger to flick in some weeds in a value that contrasts with the foreground color and add little dots for texture.

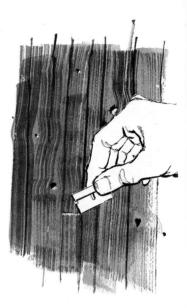

STEP FOUR

- Lightly restore the grain in the sunlit areas.
- 2 Paint the cracks in the boards and darken the knotholes.
- Add a little splatter and scrape out some highlights.
- 4 Flick in some weeds and add dots for texture.

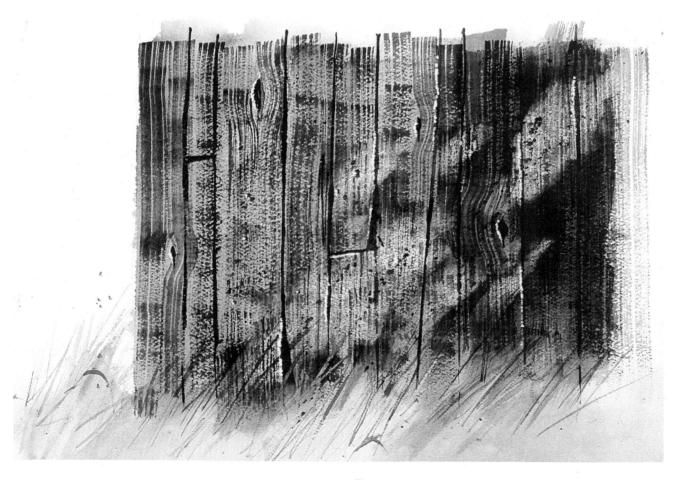

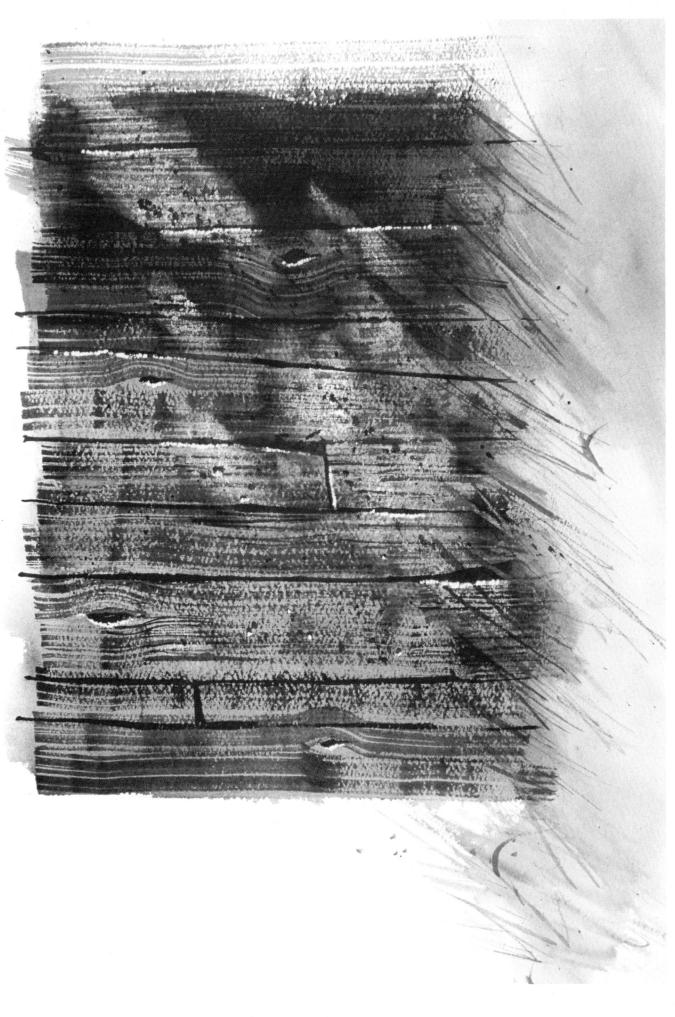

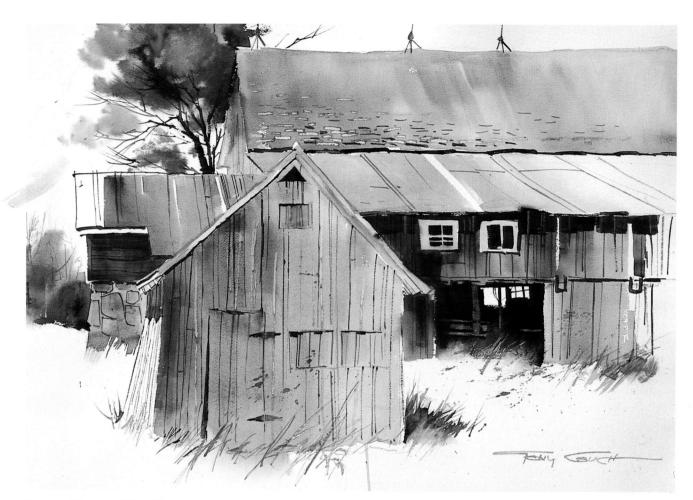

Vermont Vignette 22" x 30"

Barns have always been favorite subject matter for watercolorists. In this project you will learn to paint a simple barn and silo, which will teach all you need to know to tackle more complex barnyard structures. One very important principle that I use here is the principle of gradation. Notice how I graded many of the areas from light to dark and from warm to cool. This adds interesting variety to the painting, and renders the effects of reflected light. (Use template on page 73.) sing the large flat brush and clean water, wet the entire side of the barn and the cupola, avoiding the edges. Lay in a wash with the blue with a little purple in it (ultramarine) starting on the left. Make it cool and dark but gradually add raw sienna and water as you paint toward the right so it becomes warmer in color and lighter

in value. The dark edge against the sunlit side of the barn is called a "planechange accent" and lends drama to the barn. While the paint is still wet, but no longer glistening, scrape in a few cracks between the boards with the edge of a razor blade.

STEP ONE

- 1 Wet the entire side of the barn and the cupola.
- 2 Wash in the side of the barn, cool and dark on the left, gradually warm and light on the right.

Next, paint the cupola. Notice that it has the same plane-change accent and the same change in color and value as the side of the barn.

- **3** Scrape in a few boards with a razor blade.
- 4 Paint the cupola like the side of the barn

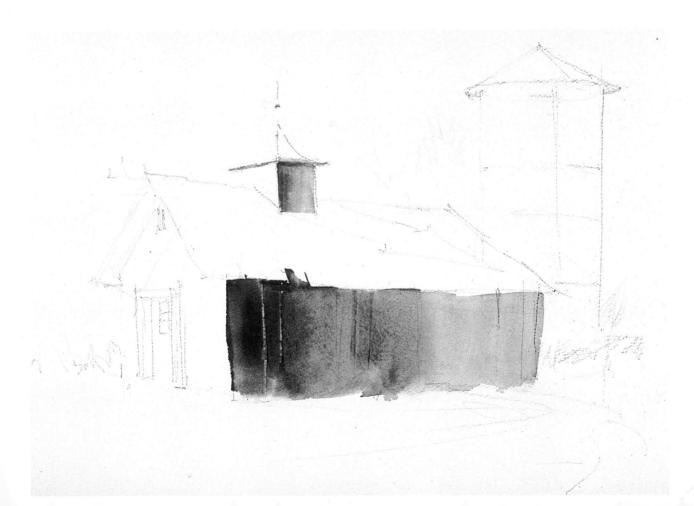

et the silo with clean water, avoiding the edges. Mix a dark, cool color and first paint the dark dry on wet core of the shadow down the right third. Then with a wet on wet technique carry this wash to the right edge, making it lighter at that edge and warmer and lighter as you approach the bottom, to show reflected light from the ground. While the core is still wet, use a clean wet brush to soften the edge toward the light source.

While the silo is still wet,

use the point of the knife to scrape the bands around it. Start in the shadow side and drag some of the color into the light area. It will leave a light mark in the dark area and a dark line in the light area. Be careful to make the bands horizontal at eye level and slightly curved near the top, to describe its roundness.

STEP TWO

Wet the silo with clean water. Paint the soft edged dark core, making it lighter and warmer at the bottom.

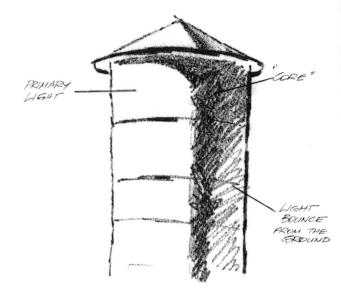

2 Use the point of the knife to scrape in the bands around it.

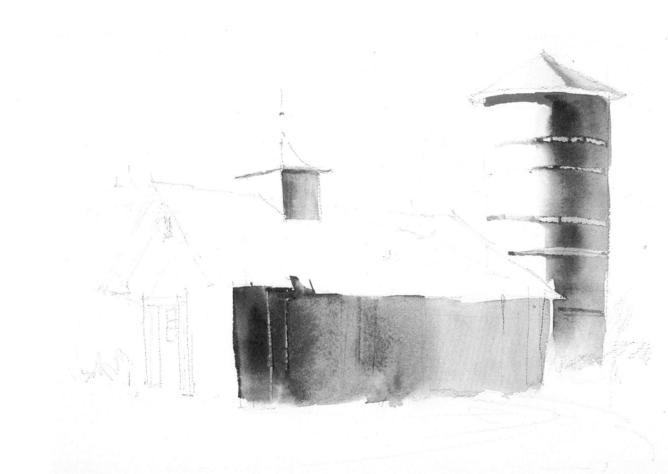

he side of the barn in the light is left the white of the paper to give the illusion of bright sunlight, except for the cast shadow from the eave of the roof. The underside of the eave is out of the direct sunlight, so it will have some value. Wet that area with clean water, avoiding the edges. Then paint in any warm color (I used yellow ochre) making it light at the bottom and gradually white paper at the top. While this is still wet, paint a darker ultramarine blue at the top, gradually lighter at the bottom where it blends with the yellow ochre. This results in a light warm at the bottom, gradually becoming a darker and

cooler color at the top—creating the illusion of warm light bouncing off the ground. The blue top also adds contrast.

Now paint in the cast shadow on the sunlit side of the barn with a cool hue, wet on dry. Remember to scrape the cracks between the boards into this cast shadow. Next paint in the shadow around the door frame,

changing the temperature and value from warm and lighter at the bottom to cooler and darker at the top. Now put in the cast shadow on the door. Try to do all this with as few strokes as possible, to keep it crisp. The less you fool with it, the better it will look.

Since the roof is going to be brown/red to create the illusion of rusted tin, and any cast shadows on it will merely be a darker version of the surface color, mix a darker brown color with burnt sienna and black. Now paint the cast shadow of the cupola, pointing away from the light source. Use the razor blade to scrape in the lines of the roof into this cast shadow. Paint the cupola roof "rusted tin" color; I used red.

STEP THREE

- Paint the underside of the eave and its cast shadow on the sunlit side of the barn.
- 2 Paint the door frame and the cast shadow on the door.
- Paint the shadow cast by the cupola roof red.

3

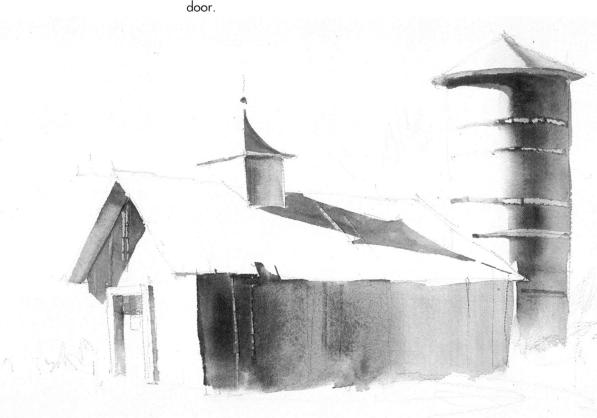

P aint the roof brown/ red; wet on dry. G r adate the value from dark on the left to white paper at the right. This makes it much more interesting than the same value all across the roof.

Wet the area above the background trees with clean water, then paint them in any hue, using them as a midvalue "foil" to describe the white right end of the roof and the white sunlit side of the silo. Run this up into the area you've wet to get soft edges for the trees. Paint the big open door on the shaded side in any warm, dark color, leaving a soft edge at the bottom. Immediately lift out a lighter area at the lower part of the door with a thirsty brush. When the paint has lost its glisten, but is still wet, use a tip of a knife to scrape in a few lines to show posts and rails inside. Use a flat brush to paint in the small window along the door. Finally, use the rigger to add calligraphic detail such as the lines along the roof, the branches of the tree, the louvers in the cupola, and details around the window. Paint the tracks leading to the door. Use the razor blade or rigger to stamp in or paint the weather vane and the cracks between the boards on the front and side and tin sections on the roof. Remember to vary the intervals between them.

STEP FOUR

- Paint the roof brown/ red, gradating it from dark to light.
- 2 Paint the tree to describe the roof and silo.
- 3 Paint in the big door in warm colors and scrape in a few internal details.
- Add details to the roof, cupola, and silo. Paint tracks leading to the door.

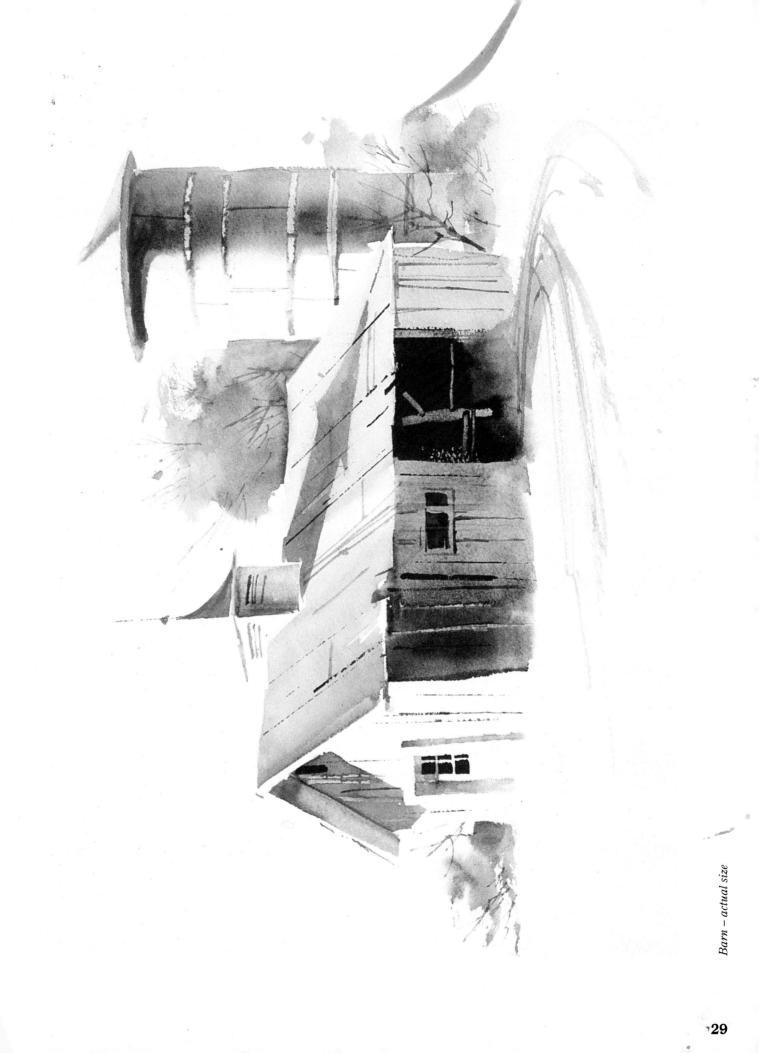

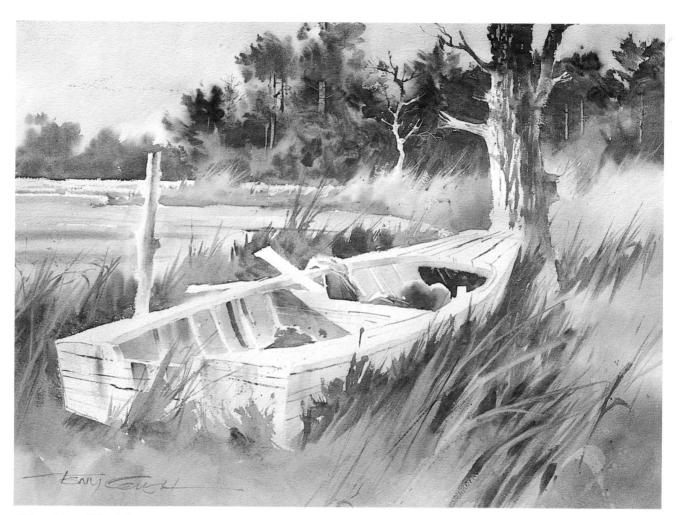

Chinco Scow 22" x 30"

Here is a way to paint weeds, reeds, and tall grasses, common elements in landscape painting. In this project, the foreground is filled with them as they sway in the wind. I painted the foreground in warm colors, so it appears closer to the viewer; the small background scene is painted with cooler colors so it remains in the distance. Varying the size, color, and spacing of the grasses make them more interesting to the eye. It may look casual and accidental, but it was done intentionally to achieve eye-pleasing variety. (Use template on page 75.) et the the entire area from the sky to the bottom of the weeds with clean water since the sky and the underpainting will be washed in with a wet on wet technique. While the paper is still glistening, float in a pale wash of blue blended with a touch of brown at the horizon. Then, while everything is still wet, paint in the basic color of the weeds. Any warm hue will do; I used burnt sienna and yellow ochre this time. Gradate the color from warm and light on the left to cooler and darker on the right by mixing in any blue. Let these colors diffuse together with soft edges. Go on to the next step while this wash is still wet.

STEP ONE

Wet the entire sheet with clear water.

2 Float in a wash of blue sky color.

Paint in the underpainting colors for the weeds, warm on the left to cool and dark on the right.

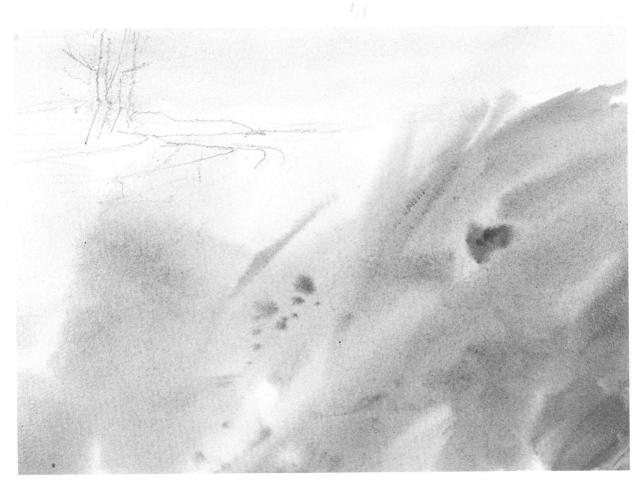

ip the 1" flat brush in clean water and squeeze it as dry as possible, then use its edge to lift out some light weeds by brushing into the still wet color. Because the paper is wet, the dry brush acts like a sponge to lift light strokes out of the paint. For more interesting variety, no two strokes should be at the same angle. However, they should all be leaning in the direction the wind is blowing. (Hint: if you're righthanded, it is easiest to make them bend toward the right.) While the paper is still wet, paint in dark weeds with the rigger, flicking them up in the direction they grow. Since the paper is wet, they will dry with soft edges. These darker weeds should also lean in the direction of the wind, be unevenly spaced and no two strokes should be at exactly the same angle. You might also vary the color, using some warm and cool colors.

STEP TWO

- Dip a flat brush in water and squeeze it almost dry.
- **2** Use its edge to lift light weeds from the still wet initial wash.

3 Paint in dark weeds with the rigger.

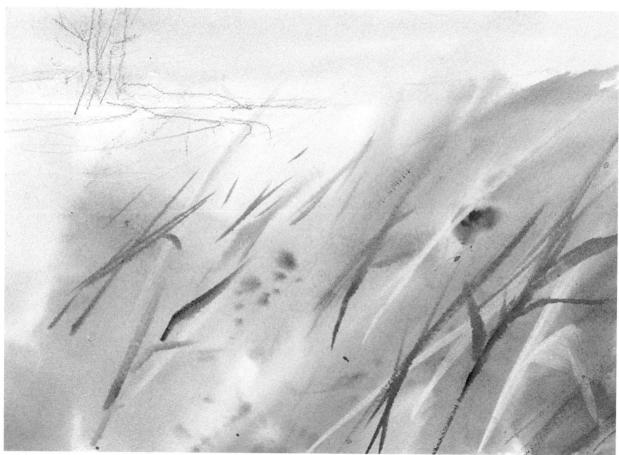

hen the painting is dry, add more weeds with your No.8 round brush. Because you are working on dry paper, the weeds will have a rough or hard texture, which contrasts with the soft textured weeds of the previous. step. Use dark and light, warm and cool colors. Remember that the weeds will

be big in the foreground and gradually smaller in the background due to perspective—use the rigger for the smallest. Also vary the spacing and angles, letting some form x's, which guarantees adjacent weeds won't be at the same angle. Add leaves to a few. For texture, splatter the foreground by hitting a brush loaded with paint against your hand.

STEP THREE

- Let the painting dry and add hard or rough textured weeds.
- **2** Vary the colors, sizes, angles, and spacing.
- Splatter the foreground for texture.

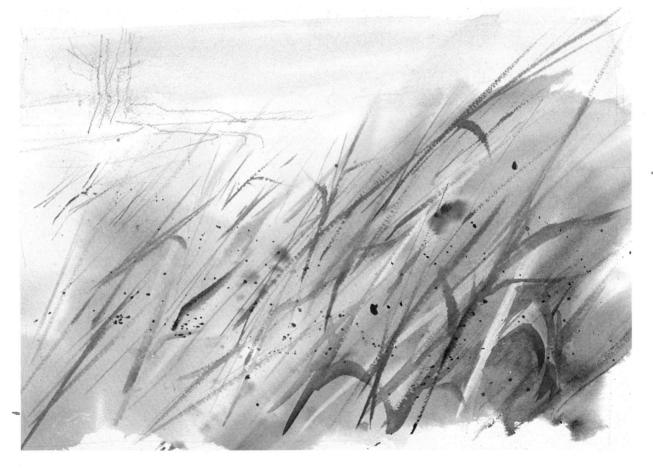

he background landscape is the last step. Making it cool and the objects small helps put it in the distance, while making it dark adds an interesting contrast to the light weeds in the foreground. Paint the hills with any dark cool color, and the trees any warm color. For contrast, make the trunks lighter at the bottom. The bottom edge of the back-

ground shape is done with fast angular strokes with a 1" flat brush into the light foreground. I used the rigger to flick in fine weeds in the foreground.

STEP FOUR

- Paint the distant hills in cool, dark colors.
- 2 Paint the trees in the background a dark, warm color.
- **3** Flick in fine weeds in the distant foreground grass.

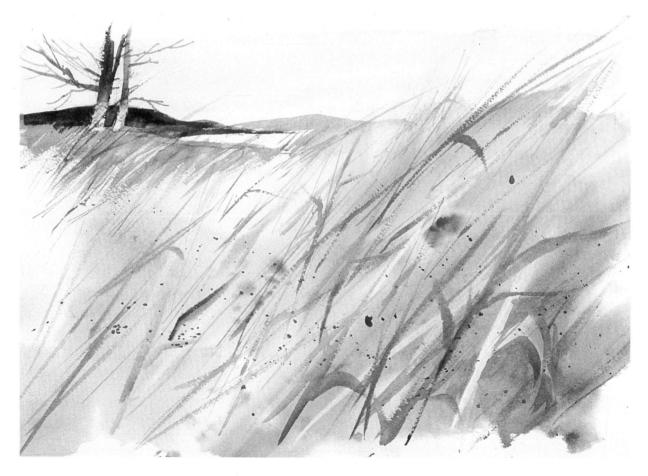

Weeds – actual size

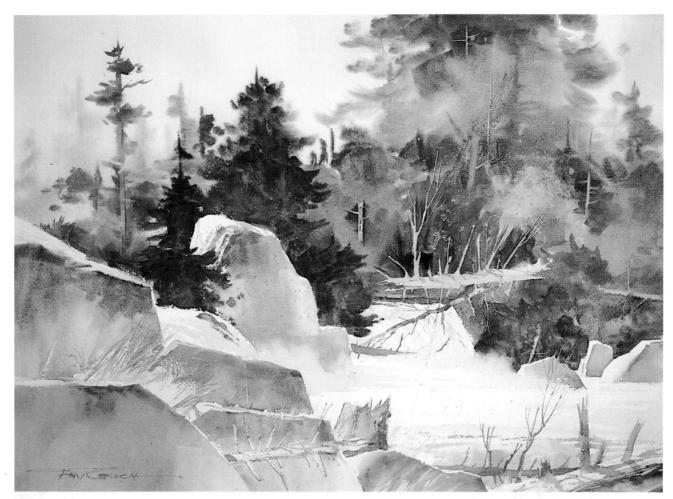

Twin Falls 22" x 30"

6 Rocks

Rocks can be prominent features of the landscape, and they are often so interesting that they can serve as the principle subject matter in your painting. In this project, you will learn how to paint rocks in bright sunlight. There are ways to make a painting of rocks say "rock," shape, texture, and color. In general, the shape should be convex and angular, which expresses hardness and durability. The texture should be sharp or rough at the edges, since it is the texture along the edges which will indicate the character and identity of the rocks. Finally, the color-could be anything except green, which would not contrast sufficiently with the surrounding grass. Usually rocks are some variety of gray, either a warm or cool gray depending on the geology of the area and the kind of light in the scene. (Use template on page 77.)

sing clear water and a clean flat brush, wet the background from the top of the paper down almost to the top edge of the rocks. While the paper is still wet, wash in a blue for the sky with a wide (I used a 2") flat brush using a wet on wet technique to get soft edges and diffused color. Immediately paint the trees in greens, blues, browns, and grays using a dry on wet technique. Remember, you want to remove most of the moisture from the brush so the pigment flows into the still wet background, but not so much as to lose the shape of the trees as would happen

using the wet-in-wet technique. Paint down to the edge of the rocks. Since the paper was left dry at that point, you can make a hard or rough edge along the top of the rocks. While the backgound is still wet, use any flat brush and clean water to soften the edges on either side of the rocks where it joins the foreground.

While the paper is still wet

STEP ONE

- Wet the background down to the top edge of the rocks.
- 2 Wash in the sky and paint the trees dry on wet.

but has lost its glisten, scrape with the point of the pocketknife up into the background along this edge for weeds. Use a razor blade and squeegee out wide lines for the large pine trunks on the center right. The corner of a razor blade or a knife is used to scrape in the light limbs.

Scrape in some weeds
on the foreground

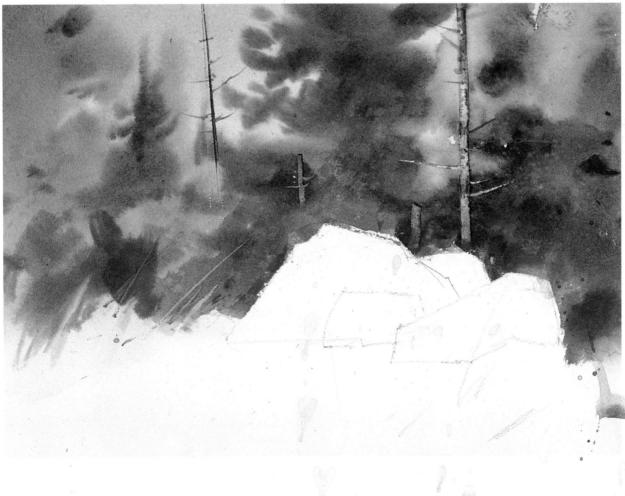

ere we will establish the direction of the sunlight upon the rocks. In this instance, the light is coming toward you from the left.

Wet the first big rock on the left with clear water down to the edge of the next rock and paint the part out of the sunlight with a cool middle value, leaving the sunlit top surface of the rock white (unpainted). Make the top darker, grading it to lighter and warmer near the ground. Use a brush and clean water to soften the top of this area to create the illusion of a rounded edge. Then do the rocks one at a time following the same procedure, beginning with the small rock at the top, behind the big rock. For this shaded area, make the color warmer for contrast and dark above the top edge of the rock in front, to separate them. Next, paint in the shaded area on the small middle rock using a warmer color for variety. Remember to vary the colors of the shaded areas on all the rocks by mixing them on the wet paper instead of the palette. To give the illusion that some of the rocks are hard and angular instead of rounded, make the edge of the shaded area against the sunlit surface rough by pushing forward with the tip of the flat brush. While the shaded areas on the foreground rocks are still wet, use a clean brush and clear water to soften the edge along the bottom and scrape in some weeds with a knife.

STEP TWO

- Wet the first big rock and paint in the shadow.
- 2 Do the same for the remaining rocks, contrasting warm and cool colors.
- 3 Scrape in some weeds on the foreground rocks.

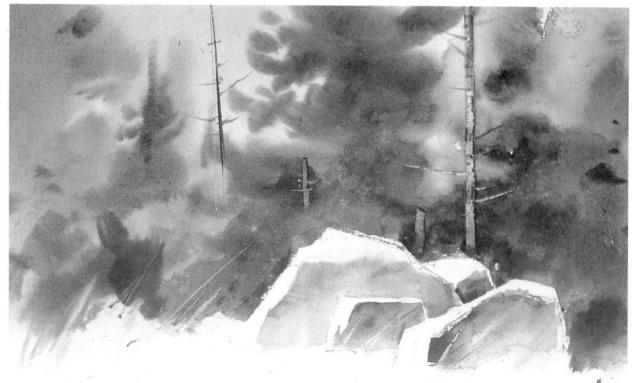

ince the sunlight comes from behind the trees in the background, the trees cast shadows on the rocks. Use the No. 6 round brush and a color about the same value as the shaded `areas to paint the cast shadows, following the contours of the rocks to suggest their shapes. Remember that all the shadows should fall in a direction consistent with the light source. Use a clean brush and clear water to soften the shadows where they blend with the shadow side of the rocks.

STEP THREE

- 1 Paint in the cast shadows from the trees.
- 2 Follow the contours of the rocks to suggest their shapes.

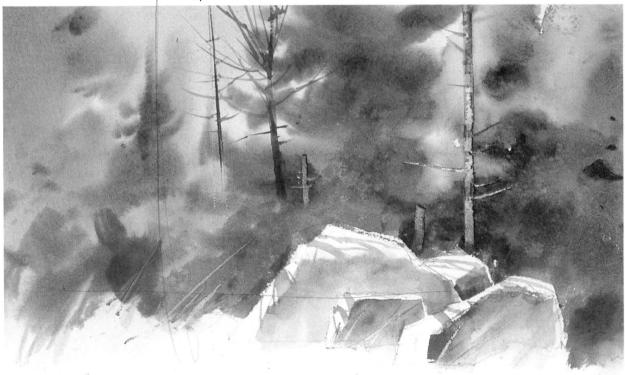

he foreground weeds and grasses are painted using many of the techniques described in Project One. The overall value of the foreground is lighter than the overall background. Begin by wetting the whole foreground with clean water with any big brush. Using a weton-wet technique, float in warm colors and gradate the value from light on the left to darker on the right. Use the

rigger to flick in some dark, soft-textured weeds while the paper is still wet using a dry on wet technique. Splatter some texture into the foreground. When everything is dry, add details to the foreground. Use the rigger for hard-textured weeds.

STEP FOUR

- Wet the foreground with water.
- 2 Float in warm colors, graduating to darker on the right.
- **3** Flick in dark weeds and add splatter for texture.

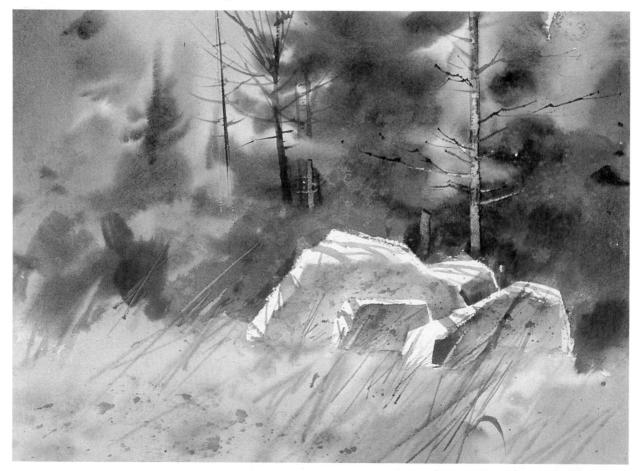

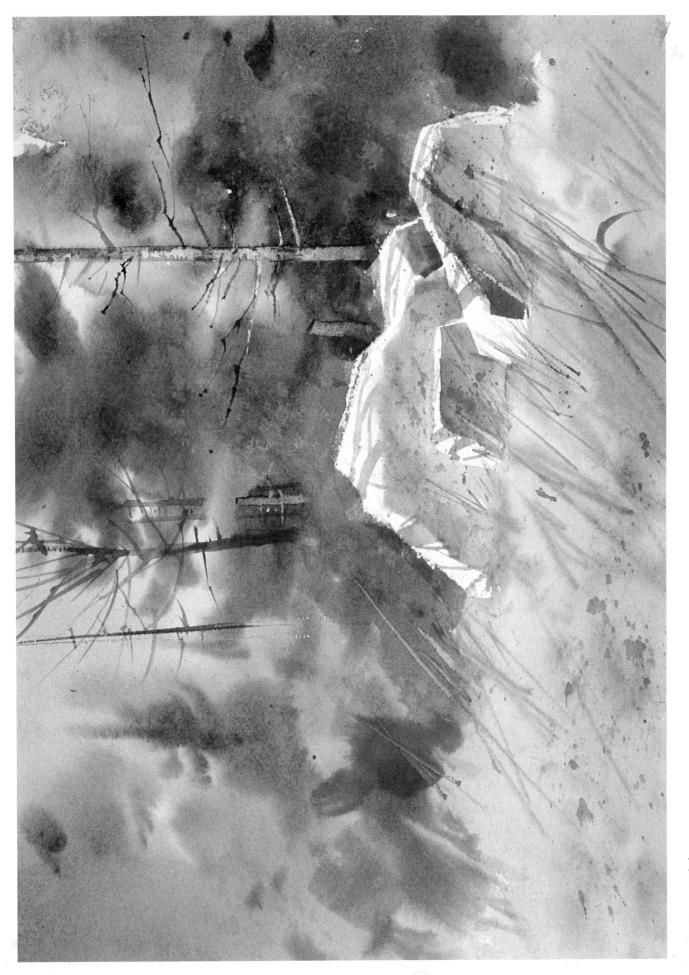

Rocks – actual size

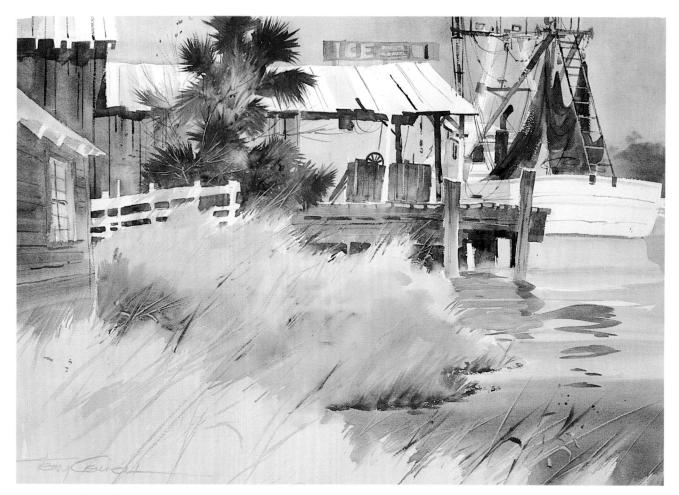

Alongside 22" x 30"

7 Palm Trees

Palm trees are so different and distinctive, they should be in every watercolorist's repertoire. Once again, I will demonstrate how to paint the symbol of a palm tree. If you paint landscapes in the warmer, tropical climes, palms trees will add a characteristic touch to your compositions. There are many different species of palms, but you can adapt the techniques shown in this project to paint them all. Pay particular attention to the silhouette of the species of tree you want to paint, because it is its unique shape that will identify it. (Use template on page 79.)

Begin by wetting the foliage mass at the top of the tree with clean water, but avoid the edges. Mix an olive green from black and any yellow. Then using a No. 8 or so round brush and a medium value of this green, paint in the fronds. Flick outward in a starburst pattern from the wet area of the tree onto the still dry paper around it to get rough or hard edges and pointed frondlike shapes. Notice how the fronds are being blown in the same direction. While the wash is still wet, use a "thirsty" round brush to wipe out some lightcolored fronds in front of the leaf mass.

STEP ONE

- 1 Wet the frond area at the top of the tree with clean water.
- 2 Paint in the fronds with olive green, flicking out in a starburst pattern.
- 3 While this is still wet, use a thirsty brush to wipe out light-colored fronds in front.

ix a darker value of the olive green and with a dry on wet technique, add some dark fronds along the bottom and edges of the leaf mass, flicking outward onto dry paper. Change to a cool color like ultramarine mixed with a little burnt sienna or brown and add the mass of dead leaves hanging beneath the crown of fronds. While these colors are still wet, use the tip_of_the_pocketknife_to scrape out light fronds, exposing_the_lighter_colors applied in step 1. Remember to keep the direction consistent with the way the wind is blowing.

STEP TWO

- Add dark fronds along the bottom and edges of the leaf mass.
- 2 With a cool color and warm brown, add the mass of dead leaves.
- **3** Use the pocketknife to scrape out some lighter fronds.

se clean water to wet the trunk. You are going to paint the trunk with a cool color at the top (to reflect the sky and contrast with the brown mass of leaves), gradually changing to a warmer color created by light bouncing off the ground at the bottom. Use a brown to paint the broken stems along the top of the trunk; use the pocketknife to scrape some out in the front and to scrape some horizontal bands near the bottom to describe the roundness of the trunk.

STEP THREE

- Wet the trunk with clean water.
- 2 Paint the trunk with a cool color at the top, gradually warmer at the bottom.
- **3** Paint the broken stems along the top and scrape horizontal bands near the bottom.

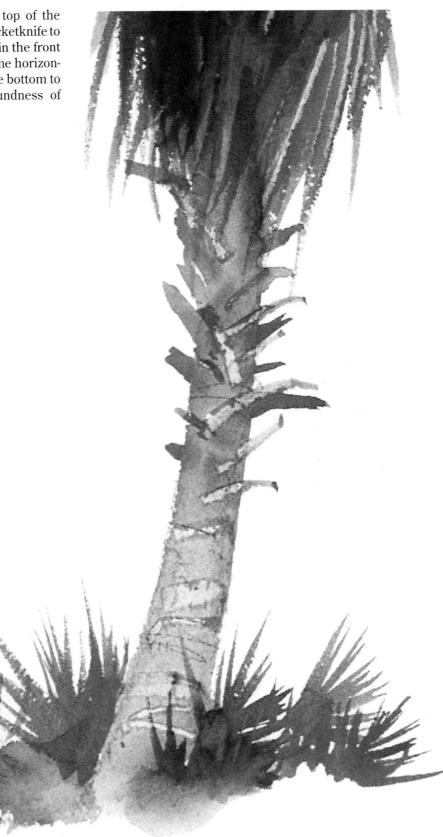

PALM TREES

sing greens similar to the colors of the fronds, with the small round brush paint small starbursts of grasses and palmetto fronds along either side of the base of the trunk. Make a soft edge along the ground line by taking a brush wet with clean water and wetting the bottom edge of the vegetation.

STEP FOUR

- Paint the grasses and palmetto fronds on the ground in greens similar to the tree's fronds.
- 2 Soften the edge of the ground line with a wet brush.

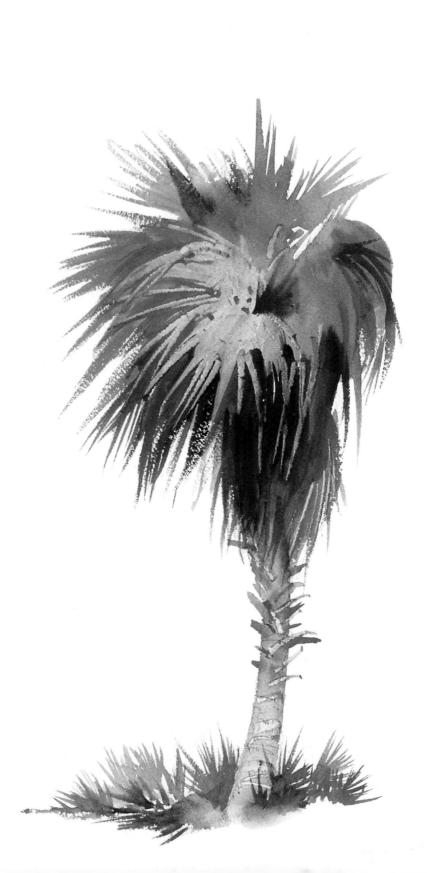

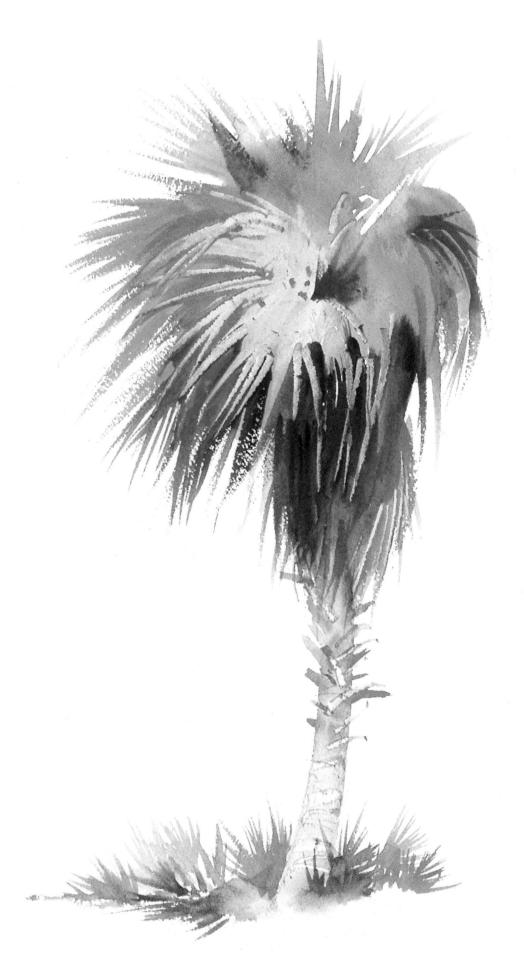

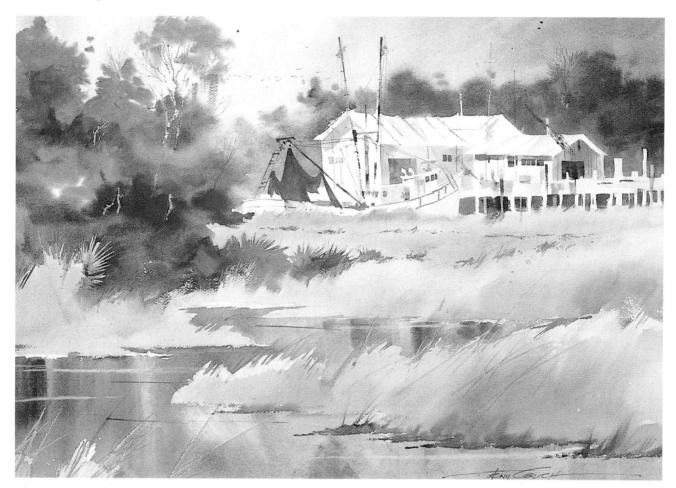

Marsh Harbor 22" x 30"

8 Still Water

Watercolor, because of its free flowing, liquid nature, is perfectly suited for painting water in its many forms. The immediacy and directness of watercolor can render the placid surface of a lake as well as the rush and energy of a waterfall. In this project, you will learn how to paint the calm motionless water of a lake on a still day. Calm water is usually darker in the foreground, where it reveals the colors of its depth, and lighter near the horizon, where it reflects the light of the sky. (Use template on page 81.)

et the background from the top of the paper to the horizon. Using the flat brush, paint in the sky with the blue with green in it using a wet on wet technique. The value should be light. Then, use a purple mixed from ultramarine blue and alizarin crimson in it to paint in the distant mountain. The cool color creates atmospheric perspective. The top edge of this mountain is soft against wet paper and the bottom edge rough on the dry paper. Next, while the paper is still wet, paint the foliage on the right in warm colors such as yellow ochre and burnt sienna mixed with ultramarine blue, using the dry on wet technique. The edges against the sky are soft and edge at the horizon (water level) is hard and rough because the paper is dry there. Scrape in the light tree trunks with a knife, and add tree limbs and details with a rigger while the paper is still wet.

STEP ONE

- Wet the background from the top to the horizon.
- 2 Paint in the sky wet on wet and paint the distant mountain.
- Paint the trees at right wet on wet.

3

4

Scrape in the light tree trunks with a knife.

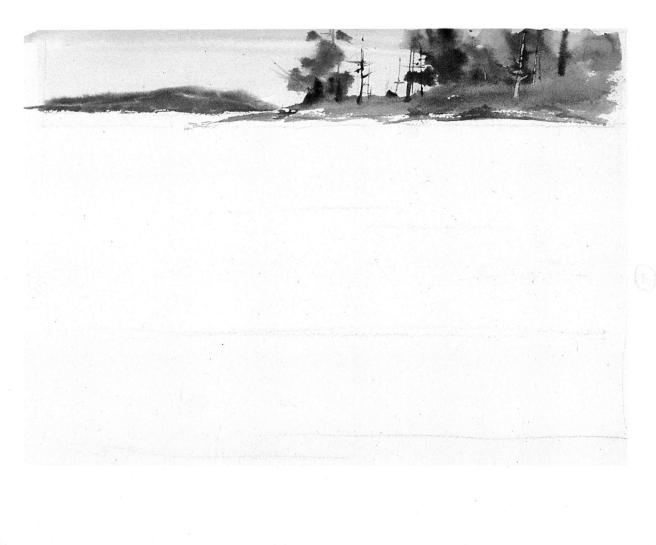

ainting the water for D this project is an excellent exercise in creating a graded wash. Begin by wetting the entire water area, with the blue with purple in it and a large flat brush, and wash in the blue in long horizontal strokes. Start at the bottom and work to the top in a series of overlapping strokes, making the blue darker at the bottom, gradually lighter at the top. While the wash is still wet, take a clean flat brush and squeeze

all of the water out of it. Place the edge of the bristles horizontally against the paper and make long horizontal strokes, lifting out light lines to indicate slight swells of water reflecting the sky. Make only two or three strokes in the middle and bottom. Experiment a bit with the timing—if the wash is too wet, the stroke will close up and disappear; if it's too dry, the brush will not pick up any paint and no stroke will appear at all. Go on to Step 3 while the paint is still wet.

STEP TWO

- Wet the water area with a pale blue tint, making it gradually darker at the bottom.
- Dip a clean brush in water, squeeze dry, and lift streaks of color to indicate swells.

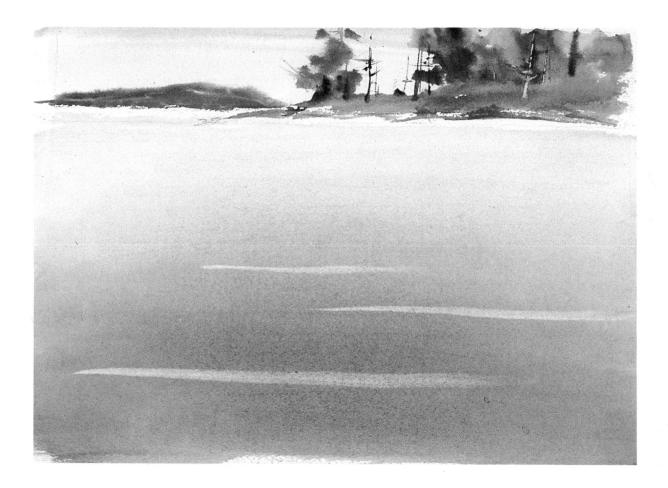

R eflections appear immediately below the reflected objects. To paint the reflections of the trees, mix color similar to the trees. While the large water area wash is still wet, pick up the approximate colors of the trees in a 1/2" or so flat brush and stroke directly down, perpendicular to the horizon. Since the paper is wet, the strokes will diffuse slightly into soft-edged forms. While these reflections are still wet, take a clean, dry flat brush and make straight horizontal strokes from right to left so that some of the reflected color is dragged into the water color. Remember to vary the length and spacing of the strokes for variety. Also make sure the strokes are exactly straight and horizontal. The more distant strokes should be shorter, narrower, and closer together. If the paper is not very wet when you get to this last step, let it dry "bone dry." Then rewet it with the 1" flat and clean water with as few strokes as possible and paint as described above.

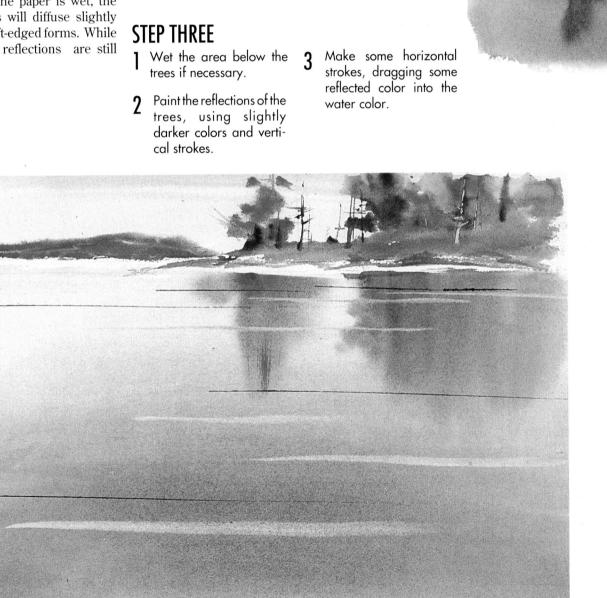

or the final details, take a razor blade and pick up a dark color from the palette by scraping it into a puddle of paint. Any color will do as long as it's very dark. Place the blade so it is horizontal and drag it along its edge, leaving a very thin dark horizontal line to indicate the darker side of small waves. Be sure the paper is "bone dry" before you do this. Otherwise these lines will diffuse. Remember to space them farther apart nearer the bottom, that is, closer to the foreground. Finally, use the rigger brush to paint in some weeds in the foreground.

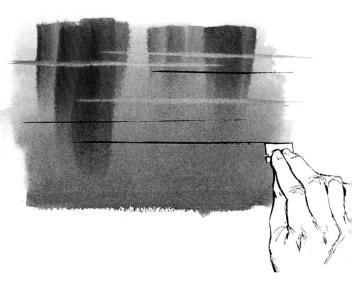

STEP FOUR

- When the paper is dry, pick up any color with the razor blade.
- 2 Drag it along its edge to indicate the darker side of small waves.
- 3 Use the rigger to paint in the foreground.

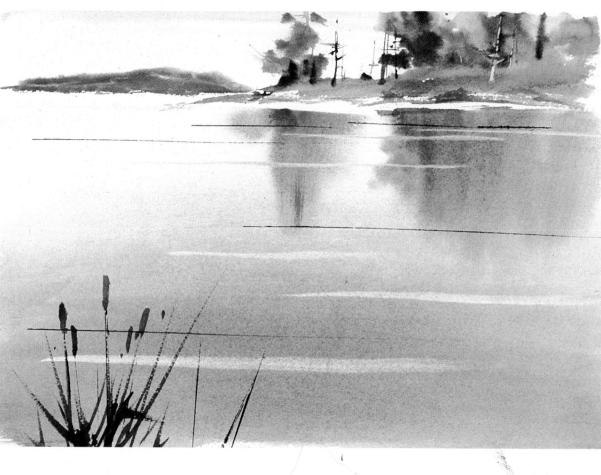

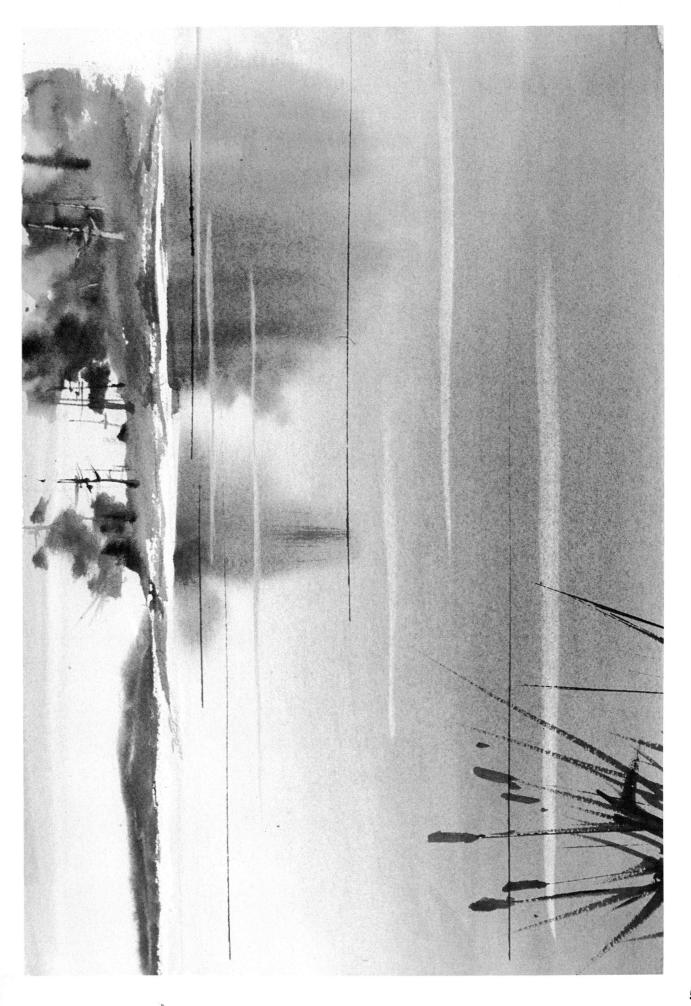

Still Water – actual size

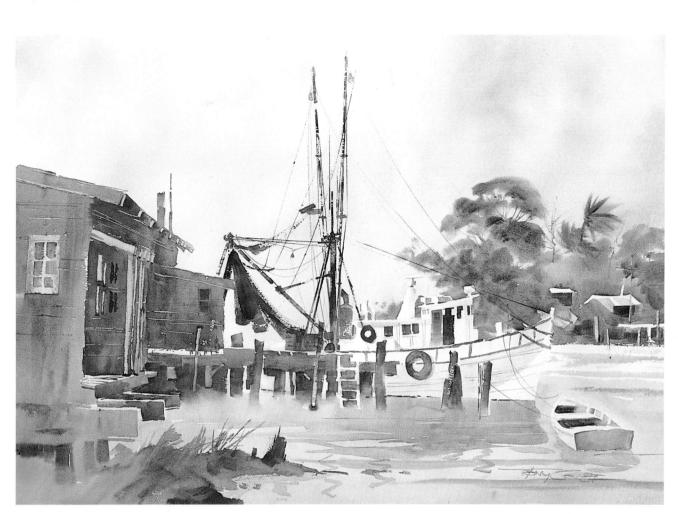

```
Fernandina Stop 22" x 30"
```

9 Water In Motion

In this project, you will learn to paint water with some motion created by the action of the wind on the water's surface. The rippling of the water's surface will catch the light in ways different from still water. In this demonstration, the sparkle of sunlight on the horizon is created by using a dry brush technique on the pure white paper. The zigzag curves of the reflections in the foreground reinforce the illusion of motion in the water. (Use template on page 83.)

et the sky with the large flat brush down to the horizon line on the left and down to the roof line and dock on the right. Mix a grayish sky color with black or a combination of a blue, a red, and vellow ochre and wash in the sky where the paper is wet. Using the flat brush and a variety of warm colors and

grays, paint in the buildings

and the pilings. Notice how

the white of the paper is preserved for the roofs and dock. While the paint is still wet, use the razor blade to scrape in some pilings and other details. There is no need to duplicate the way I painted the buildings and pilings exactly.

STEP ONE

- Wet the sky down to the 1 horizon at the left and to the roof at the right and wash in a grayish sky color.
- 2 With browns and warm grays, paint in the buildings and pilings.
- Use the razor blade to scrape out pilings while the paint is wet.

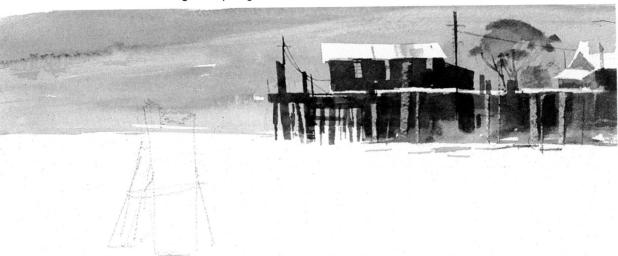

WATER IN MOTION

sing the same colors that were mixed for the gray of the sky, wash in the water. Add some warm (brown) streaks to the foreground to balance the warm dock and buildings. To get the whites reflecting off the surface of the water near the horizon, use a dry brush technique so that color is deposited on the grain of the paper leaving a rough textured pattern of white paper. While the wash is still wet use a thirsty flat brush or clean sponge to lift out some light streaks in the foreground. Remember: don't fiddle! Get in and get out.

STEP TWO

- With the gray sky color, wash in the water.
- 2 Streak in darker waves with the large round brush.
- Use a thirsty flat brush to lift out light streaks.

3

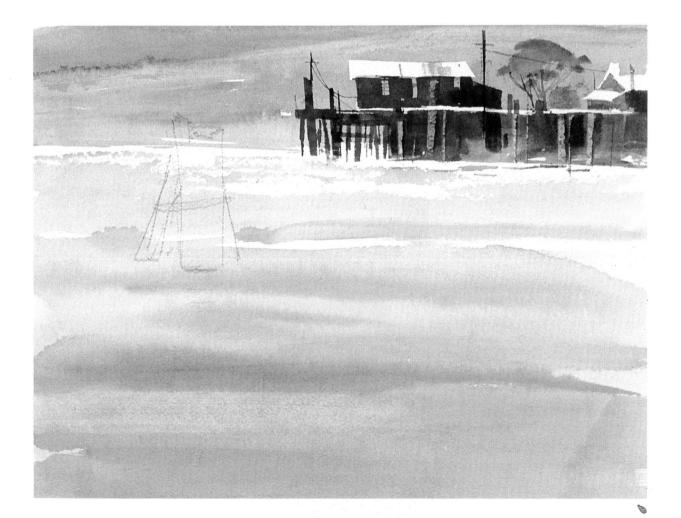

wwwwww.endotedimensional and blue, cool and dark at the top, warm and light at the bottom. I used a rapid stroke to get a rough edge on some of the central piling. I used the razor blade to scrape some texture into the piling on the left and scraped in the ropes around the pilings with the tip of the pocketknife.

STEP THREE

Paint the foreground pilings with a wet on dry technique, leaving some edges hard and others rough.

Use a pocketknife to scrape in the ropes.

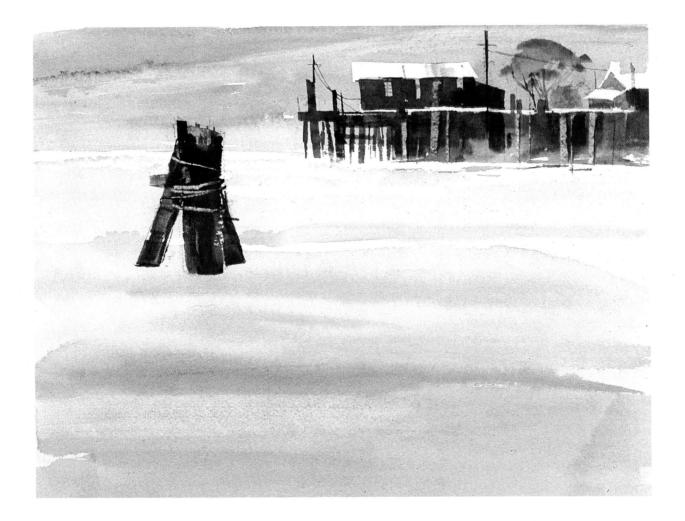

Sing a flat brush and a slightly darker version of the color on the pilings, paint in the reflection of the pilings with a wavy motion. Note where the reflection is interrupted by a wave catching the light of the sky, which is shown by leaving a band of the ocean color across the reflection. While the reflection is still wet, use the clean sponge to lift out a streak and use a

thirsty flat brush to lift out the finer light lines in the reflection. Begin the stroke inside the still wet shape of the reflection and pull the brush outward so that some of the color is deposited on the water. Finally, add the rope and small piling with the small round brush. Notice how the reflections of the rope and piling are made of a disconnected series of lazy S shapes.

STEP FOUR

- Paint the reflections of the pilings in a wavy motion.
- 2 Use a clean sponge to lift a streak, and a thirsty flat brush to lift thin lines out of the reflection.
- 3 Add the rope and small piling with a rigger.

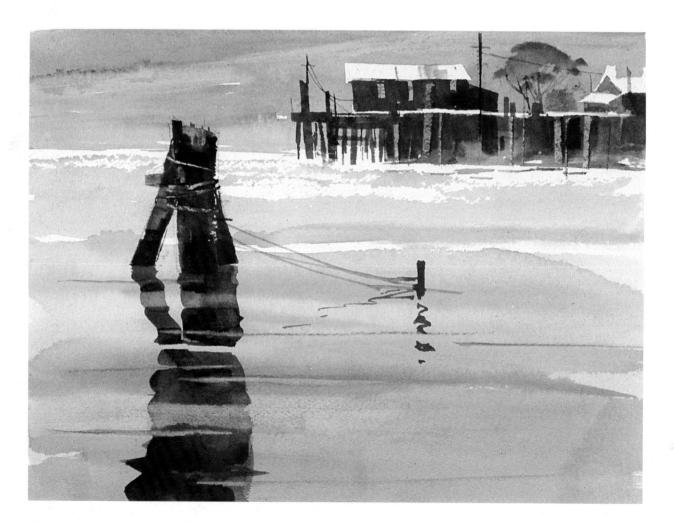

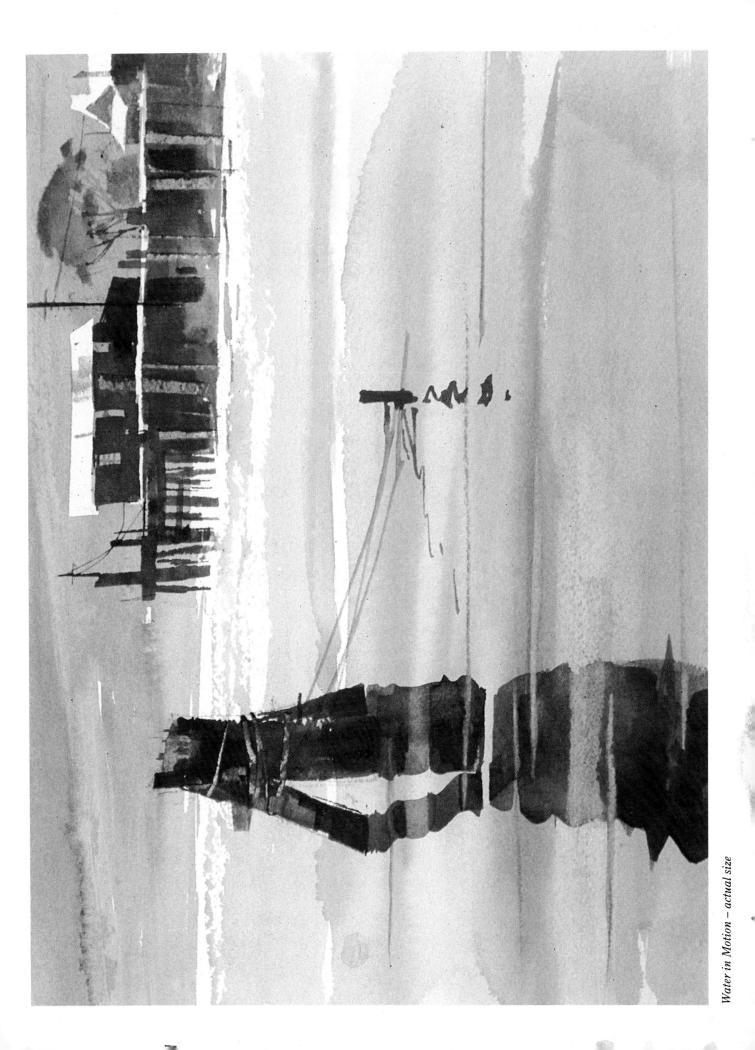

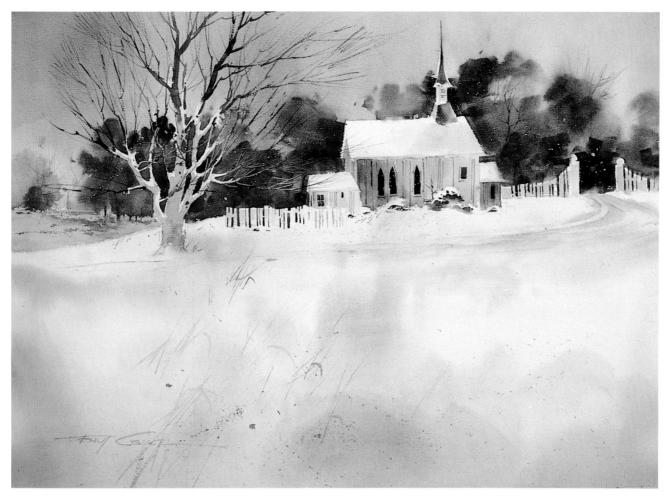

Snow Bell Prize 22" x 30"

10 Snow Scenes

The best way to express "snow" in watercolor is to make sure soft textures and cool colors are dominant in your painting. Snow shapes have a characteristic roundness and softness that contrasts with the hard and rough edges of many objects in winter. Touches of warm colors in the distant trees, and in the foreground details make the dominant cool colors look even cooler. (Use template on page 85.) S ince the white of the snow will have value other than the pure white of the paper, you will want to make the sky a bit darker than usual so that by contrast the snow looks brighter. The sky color is a cool dark mixed from the blue with a little purple in it and a bit of brown. Use a large flat brush to paint in the sky, starting at the top and painting down toward the horizon; "cut in" around the shapes of the pine tree and the horizon line. While the sky color is still wet, paint in some soft brown shapes along the horizon to represent distant trees. The brown should diffuse into soft shapes against the sky but leave a rough or soft edge at the horizon. Then scrape in the top of the tree on the far right with the tip of the pocketknife.

STEP ONE

- Paint the sky a bit darker than usual, cutting in around the shapes on the horizon.
- 2 Paint in soft brown shapes along the horizon for distant trees.
- Scrape in the top of the tree at the far right.

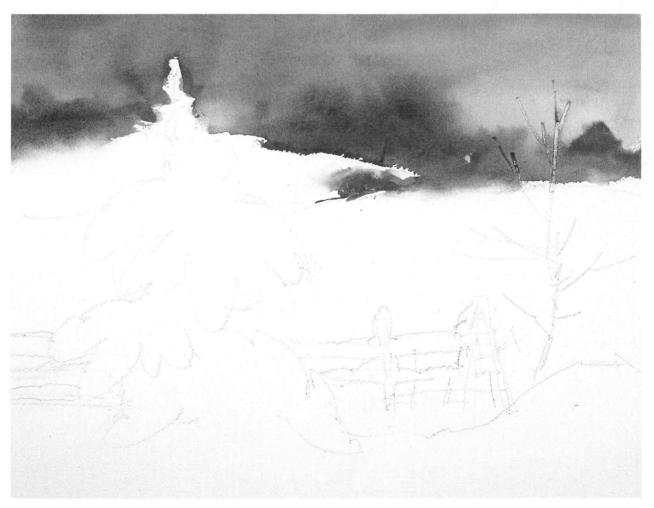

et the rest of the white paper from the horizon line down to the bottom of the sheet. Mix a very light puddle of slightly grayed blue-purple and use the wide flat brush to apply it to the entire area of snow, leaving white paper for highlights. Add a few light touches of brown for variety. Keep this wash very light and soft. Let it dry. Using a slightly darker value of the same color, paint the pine tree, fence, bare tree, and snow mounded on the rock on the right as if they were completely covered with snow. Avoid any hard or sharp angles, since snow creates round edges. The value of these shapes should be just a bit darker than the background snow.

STEP TWO

- Wet the rest of the paper down to the bottom of the sheet.
- 2 Wash in a very light, slightly grayed blue for the snow area.
- In a slightly darker value, paint in the shapes of the tree, fence, and rock.

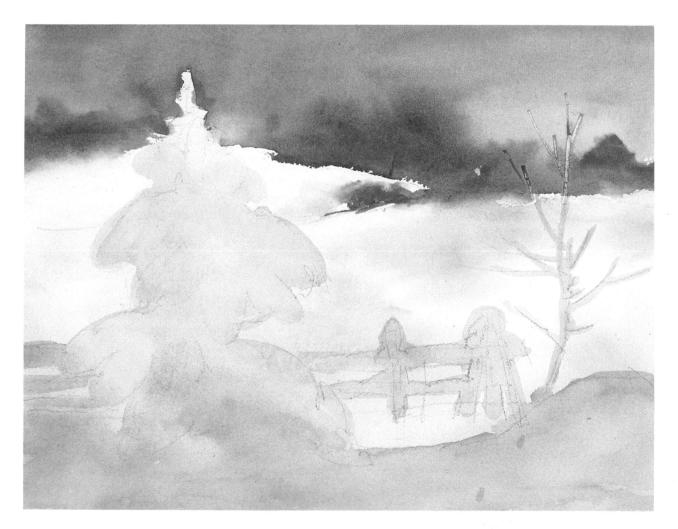

ix a dark green with the blue with green in it, cadmium yellow and brown and paint the tips of the pine tree boughs by pushing the tip of the large round brush out from the center to get a rough texture on the dry paper. Use a small round brush and clear water to get a soft or rough edge where the green emerges from the snow.

Snow will always have either of two textures: rough or soft. Remember that no two shapes should be the same size or color, and the intervals between should be varied.

The shape at the bottom of the tree should be a warm

STEP THREE

- Paint the tips of the pine tree wet on dry to get a rough texture.
- 2 Soften some of the edge where the tree meets the snow.

dark, with a soft texture along the lower edge. Use a rigger to flick out a few needles from the boughs. Paint the dark brown of the fence by pushing the tips of the bristles of the round brush against the dry paper to get a roughly textured edge.

Use a rigger to flick a few pointed needles from the boughs.

3

4 Paint the fence wet on dry to get a roughly textured edge.

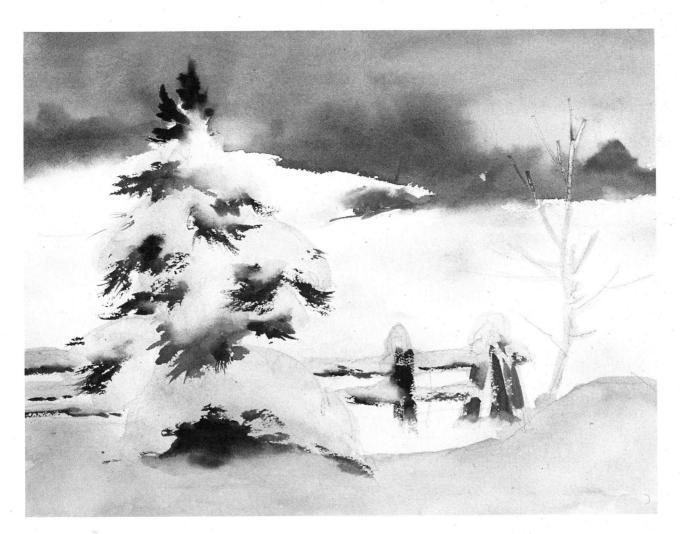

paint, put some rough tex- The rigger can also be used tured color on the rock, then to line in a few foreground soften it at the edges. Add a reeds. bit of rough texture with a light brown on the foreground snow. Finally, use the small round brush to paint in some rough texture

sing an almost dry on the small bare tree trunk brush with a little and use the rigger to flick in burntsienna and black small branches and twigs.

STEP FOUR

- With an almost dry brush, 1 add rough textured color to the rock.
- Add a bit of rough tex-2 ture with light brown in the foreground.
- Use the rigger to flick in 3 small branches and twigs and add reeds to the foreground.

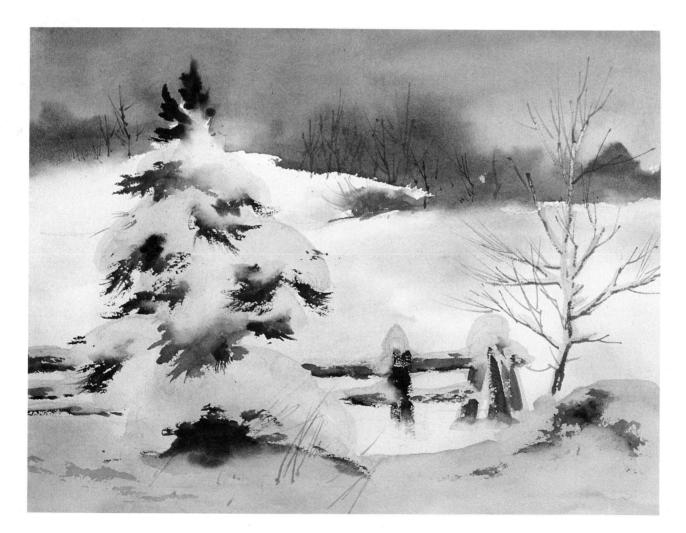

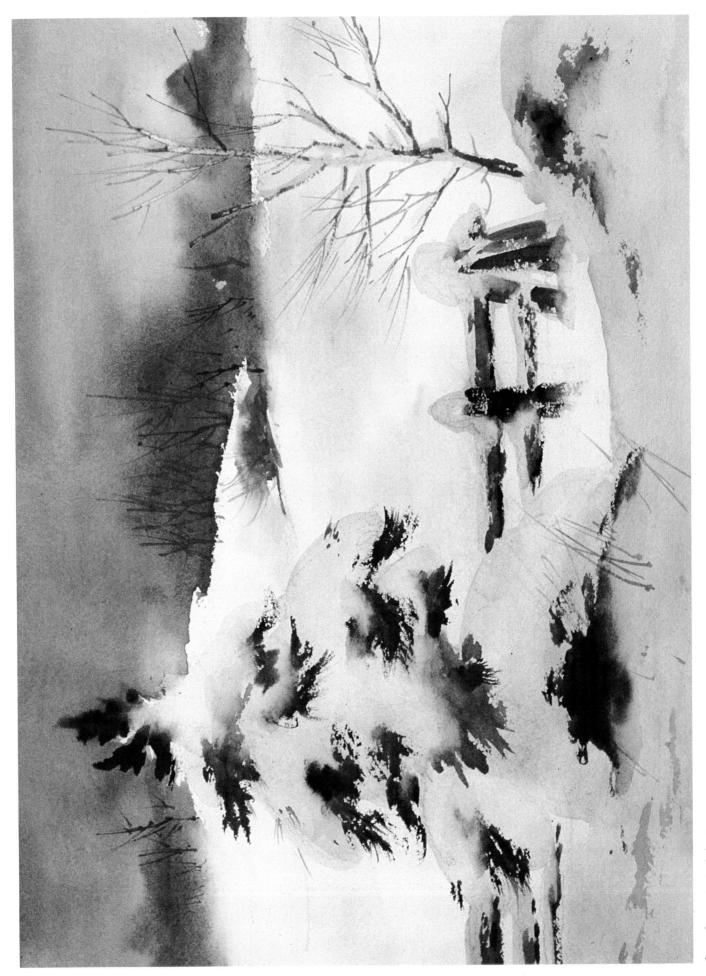

Snow Scene – actual size

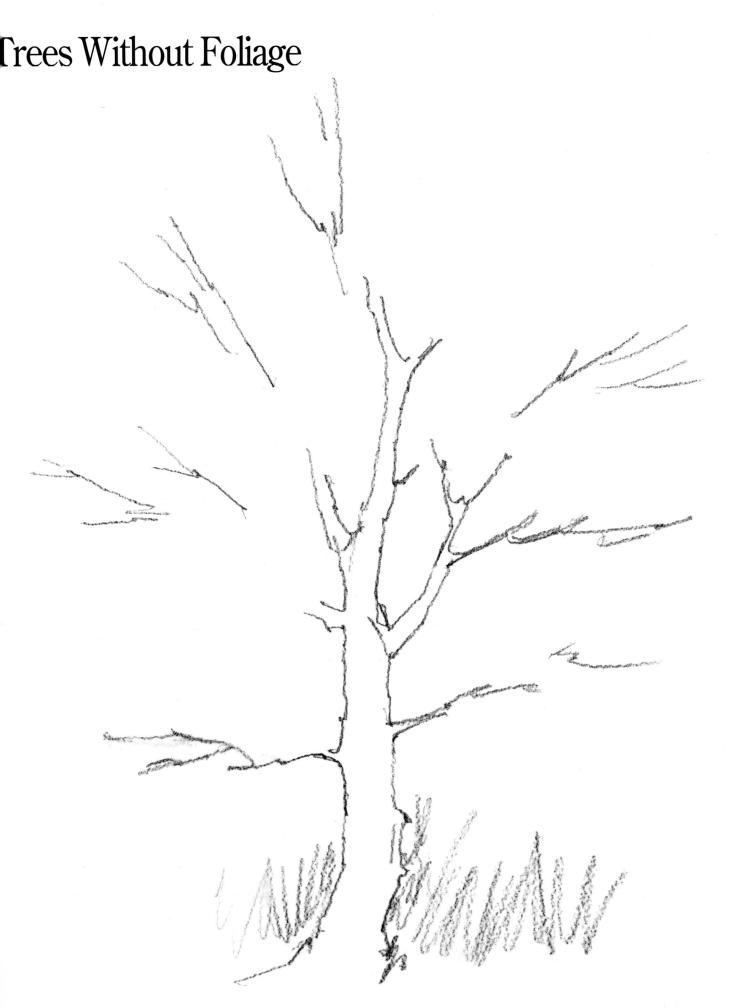

Frees With Foliage

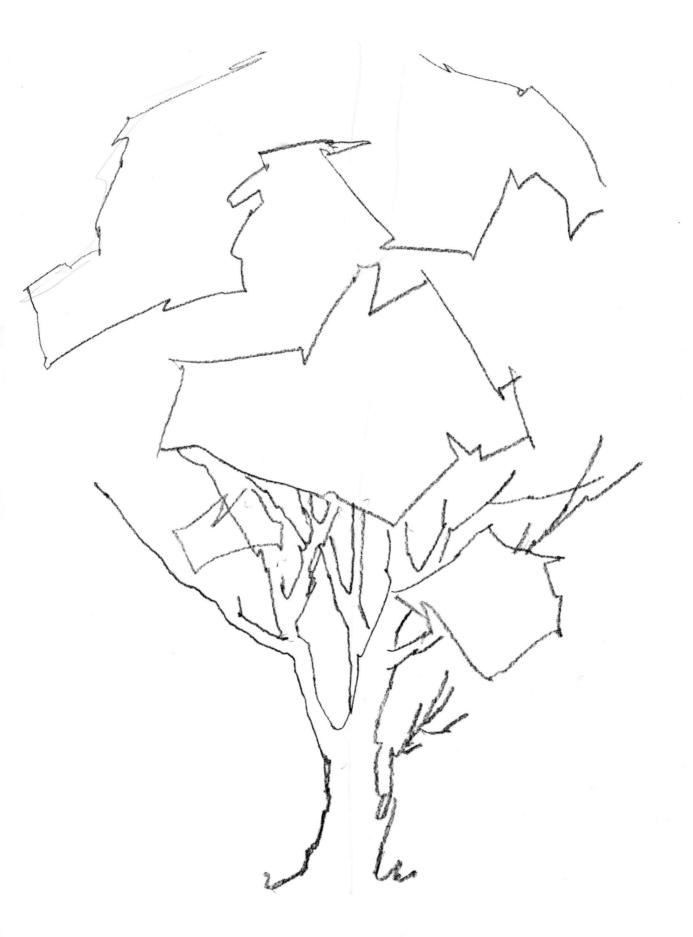

veathered wood

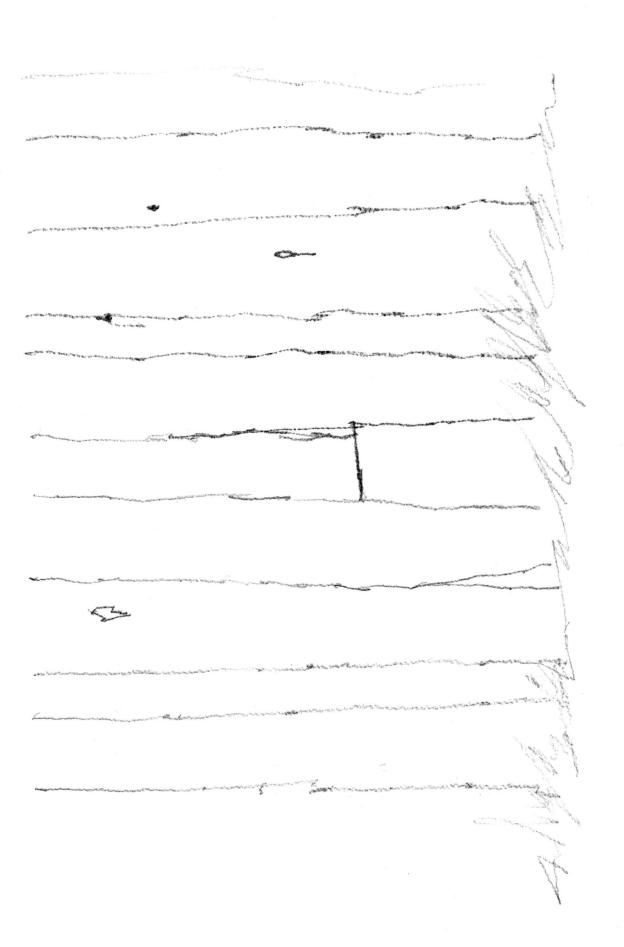

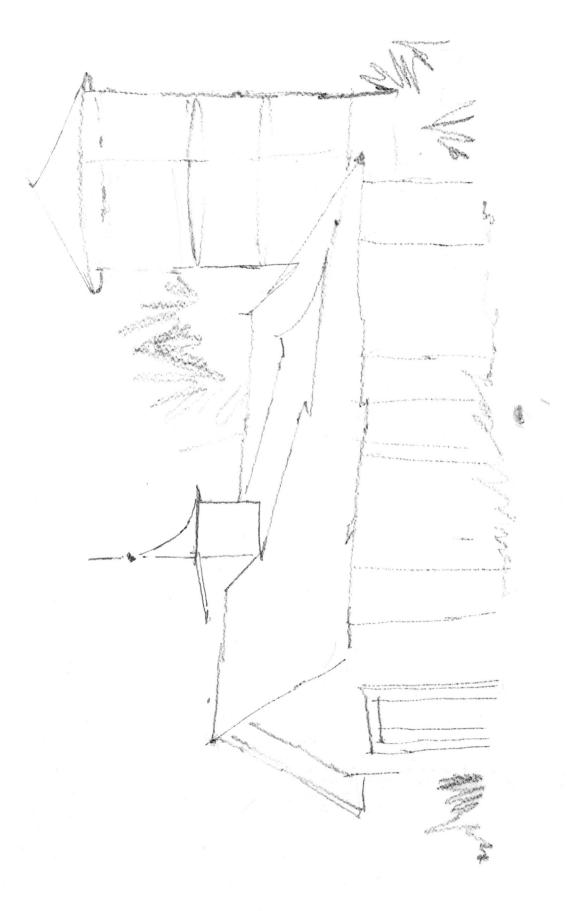

Rocks 77

Palm Trees

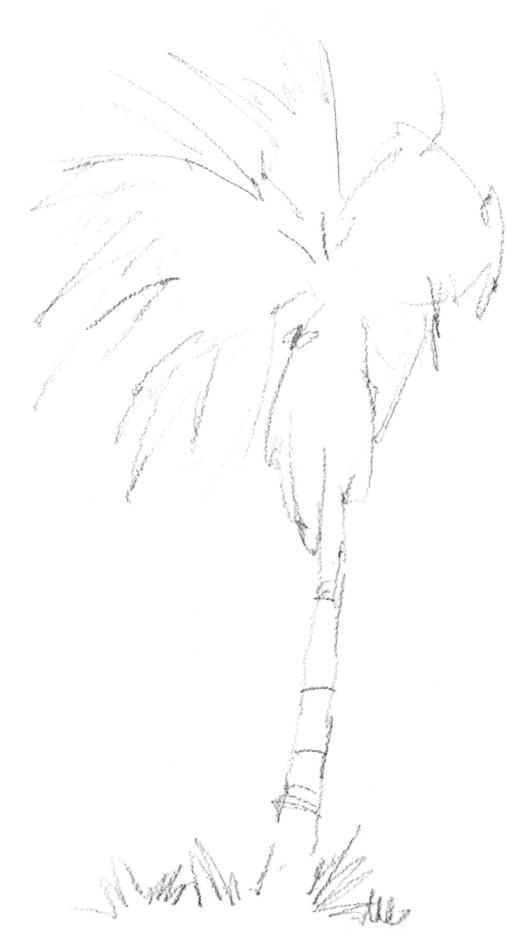

+

Show Scene

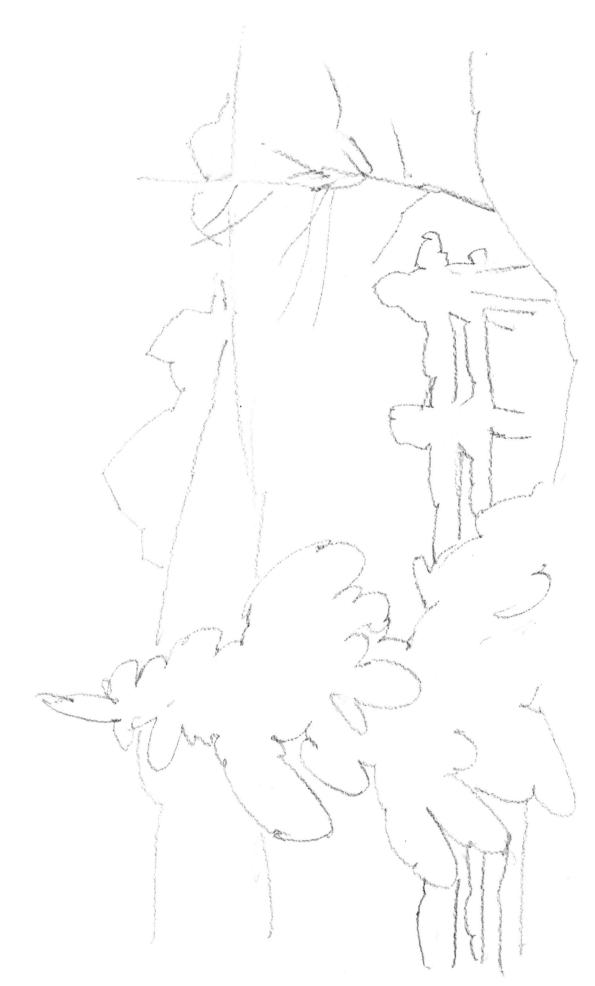

R.

Index

Atmospheric perspective, 30, 34, 48, 50

Barn, 24-29 *template for*, 69 Board, 1 Brushes, 1-2, 5 Building, distant, 55. *See also* Barn

Chroma, 2-3 Color, 2-3

Detail, simplifying, 6 Dragging, 5 Dry on wet, 3-4

Edges, 4-5 Equipment, 1-2

Fine lines, 5

Hue, 2

Intensity. See Chroma

Lift, 5 Light, 27. *See also* Lift and Sunlight

Paint, 1. *See also* Watercolor Palette, 1, 3 Palm trees, 43-47 foliage for, 43, 44 *template for,* 72 trunk for, 45 Paper, 1 Plane-change accent, 25

Reflected light, 26 Reflections, 50, 51, 56, 58 Rigger, 5 Rocks, 36-41 *template for*, 71

Scraping, 5 Shadow, 27, 39 Sky, for snow scenes, 61 Snow scenes, 60-65 *template for*, 75 Splatter, 5 Sponge, 2 Stamping, 5 Sunlight, 26, 27, 38 Templates, barn, 69 palm trees, 72 rocks, 71 snow scene, 75 trees,

with foliage, 67 without foliage, 66 water, in motion, 74 motionless, 73 weathered wood, 68 weeds, 70 Texture, 4-5 of rocks, 36, 64 of snow, 63 of wood, 18-23 Trees, as background, 37, 49 with foliage, 12-17 *template for*, 67 without foliage, 6-11 *template for*, 66 leaves, 13-15 limbs, 8, 16 trunks, 7, 15 twigs, 5, 10, 16 *See also* Palm trees

Value, 2

Water, in motion, 54-59 *template for*, 74 motionless, 48-53 *template for*, 73 Watercolor, ways to apply, 3-5 Weathered wood, 18-23 *template for*, 68 Weeds, 30-35 *template for*, 70 Wet on wet, 3 Wood grain, 21-22 Wood, grain of, 21-22 weathered, 18-23

Improve your skills, learn a new technique, with these additional books from North Light

Business of Art

Guild 7: The Designer's Reference Book of Artists \$34.95 Handbook of Pricing & Ethical Guidelines, 7th edition, by The Graphic Artist's Guild \$22.95 (paper) How to Make Money with Your Airbrush, by Joseph Sanchez \$18.95 (paper) How to Write and Illustrate Children's Books, edited by Treld Pelkey Bicknell and

Felicity Trotman, \$22.50 (cloth) Living by Your Brush Alone, by Edna Wagner Piersol \$16.95 (paper) Make Sculptures!, by Kim Solga \$11.95

Watercolor

Basic Watercolor Techniques, edited by Greg Albert & Rachel Wolf \$14.95 (paper) The Complete Watercolor Book, by Wendon Blake \$29.95 (cloth) Fill Your Watercolors with Light and Color, by Roland Roycraft \$28.95 (cloth) How to Make Watercolor Work for You, by Frank Nofer \$27.95 (cloth)

Jan Kunz Watercolor Techniques Workbook 1: Painting the Still Life, by Jan Kunz \$12.95 (paper)

Jan Kunz Watercolor Techniques Workbook 2: Painting Children's Portraits, by Jan Kunz \$12.95 (paper)

The New Spirit of Watercolor, by Mike Ward \$21.95 (paper)

Painting Nature's Details in Watercolor, by Cathy Johnson \$22.95 (paper)

Painting Watercolor Portraits That Glow, by Jan Kunz \$27.95 (cloth)

Splash I, edited by Greg Albert & Rachel Wolf \$29.95

Starting with Watercolor, by Rowland Hilder \$12.50 (cloth)

The Watercolor Fix-It Book, by Tony van Hasselt and Judi Wagner \$27.95

Watercolor Impressionists, edited by Ron Ranson \$45.00 (cloth)

The Watercolorist's Complete Guide to Color, by Tom Hill \$27.95 Watercolor Painter's Pocket Palette, edited by Moira Clinch \$15.95 (cloth)

Watercolor Workbook: Zoltan Szabo Paints Landscapes, by Zoltan Szabo \$13.95 (paper)

Watercolor Workbook: Zoltan Szabo Paints Nature, by Zoltan Szabo \$13.95 (paper) The Wilcox Guide to the Best Watercolor Paints, by Michael Wilcox \$24.95 (paper)

Mixed Media

The Artist's Complete Health & Safety Guide, by Monona Rossol \$16.95 (paper) The Artist's Guide to Using Color, by Wendon Blake \$27.95 (cloth) The Complete Acrylic Painting Book, by Wendon Blake \$29.95 (cloth) The Complete Colored Pencil Book, by Benard Poulin \$27.95 (cloth) Tony Couch's Keys to Successful Painting, by Tony Couch \$27.95 Exploring Color, by Nita Leland \$24.95 (paper) How to Paint Living Portraits, by Roberta Carter Clark \$27.95 (cloth) How to Succeed As An Artist In Your Hometown, by Stewart P. Biehl \$24.95 (paper) Keys to Drawing, by Bert Dodson \$21.95 (paper) Light: How to See It, How to Paint It, by Lucy Willis \$19.95 (paper) The North Light Illustrated Book of Painting Techniques, by Elizabeth Tate \$29.95 (cloth) Oil Painting Step by Step, by Ted Smuskiewicz \$29.95

Painting Flowers with Joyce Pike, by Joyce Pike \$27.95 (cloth) Painting the Effects of Weather, by Patricia Seligman \$27.95 Painting Towns & Cities, by Michael B. Edwards \$24.95 Painting with Acrylics, by Jenny Rodwell \$19.95 (paper) Perspective Without Pain, by Phil Metzger \$19.95

Putting People in Your Paintings, by J. Everett Draper \$19.95 (paper)

To order directly from the publisher, include \$3.00 postage and handling for one book, \$1.00 for each additional book. Allow 30 days for delivery. North Light Books

1507 Dana Avenue, Cincinnati, Ohio 45207 Credit card orders

> Call TOLL-FREE 1-800-289-0963 Prices subject to change without notice.